HOLBEIN

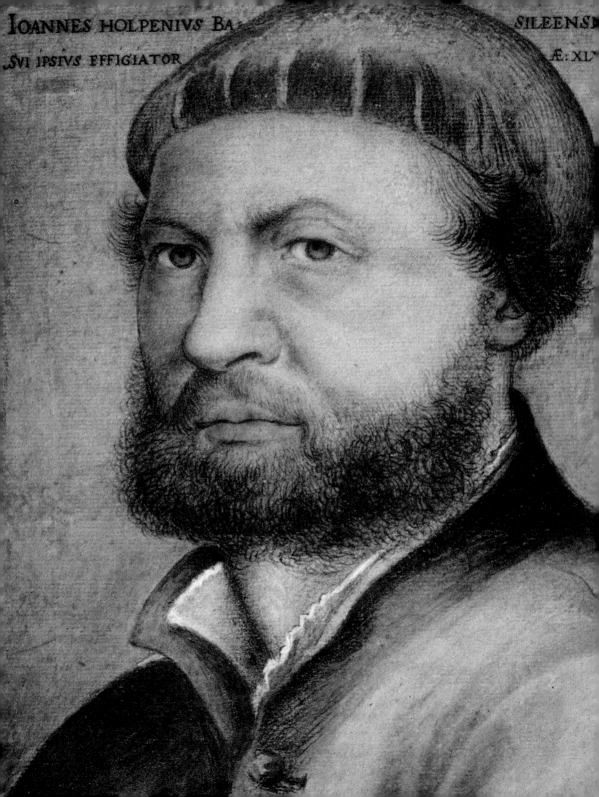

IOANNES HOLPENIVS BA· SILEENSI

SVI IPSIVS EFFIGIATOR Æ: XLV

MASTERS OF ART

HOLBEIN

Florian Heine

PRESTEL

Munich · London · New York

Front Cover: Hans Holbein, The Ambassadors, 1533 (Detail)

© Prestel Verlag, Munich · London · New York, 2022,
A member of Penguin Random House Verlagsgruppe GmbH
Neumarkter Straße 28 · 81673 Munich

Editorial direction: Constanze Holler
Translation: Jane Michael
Copyediting: Vanessa Magson-Mann, So to Speak
Production management: Andrea Cobré
Design: Florian Frohnholzer, Sofarobotnik
Typesetting: ew print & medien service gmbh
Separations: Reproline mediateam
Printing and binding: Litotipografia Alcione, Lavis
Typeface: Cera Pro
Paper: 150g Profisilk

Penguin Random House Verlagsgruppe FSC® N001967

Printed in Italy

ISBN 978-3-7913-8738-3

www.prestel.com

CONTENTS

INTRODUCTION

Hans Holbein the Younger was born in turbulent times. His life was dictated by major upheavals, the aftermath of which is still relevant even today. Art in northern Europe was caught up in the maelstrom of the Reformation which Martin Luther triggered in 1517 with his ninety-five theses. Luther's adversary was the Roman Catholic Church, which, under Julius II and Leo X, wanted to finance the building of the new St Peter's Church by the sale of indulgences. The artists were the ones to suffer most. Iconoclasm, which swept from the northern Alps across the whole of Northern Europe like a tornado, led to the destruction of countless artworks and a loss of work for many artists. The economic consequences were devastating: commissions were few and far between, and people seldom dared to instruct artists to paint religious pictures, so that the genre eventually petered out completely. An independent art market had not yet developed. Only after the Calvinist iconoclasts had once again removed all images by force from the churches in the Netherlands in the seventeenth century, could an independent art market develop and become established, in which painters were no longer dependent on the Church, princes and cities, but could sell and trade their works freely.

Holbein's contemporaries in Renaissance Italy, among them Leonardo da Vinci, Michelangelo and Raphael, were highly esteemed, much admired and well paid. At the beginning of the sixteenth century, the artists in the North also succeeded in asserting themselves: no longer did they deem themselves to be purely craftsmen, they emancipated and established themselves as artists. In 1506, Albrecht Dürer took a major step in this direction, pinpointing the problem in a letter to his friend Willibald Pirckheimer, written from Venice: "Oh, how I shall shiver as I long for the sun! Here I am a gentleman—at home I am a parasite."

Hans Holbein also benefited from this new atmosphere of awakening self-confidence. But unlike Albrecht Dürer, who wrote textbooks and studied the theory of art, Holbein was purely practical in his approach: No written statements, none of his theories have survived. Everything he had to say can be found in his drawings and paintings.

In this time of upheaval, Hans Holbein succeeded in establishing and asserting himself, and gaining recognition as an artist—independently of his beliefs and those of his clients. He tried to settle in Catholic France and eventually ended up in England. At the royal court in London he arrived in the middle of a major storm. King Henry VIII wanted a divorce, broke with the Pope and the Catholic Church, then establishing the

Anglican Church, of which he became the head. Holbein was always safe guarded by the outstanding quality of his work and evidently also by a highly developed talent for communication, without which he would hardly have achieved what he did, especially not in a foreign language.

Hans Holbein's specialty, albeit unavoidably, was painting portraits. They were the reason why he became famous and highly esteemed in the England of Henry VIII. It is thanks to these portraits that we are able to form a picture of those interesting and turbulent times. But what do they tell us today? What would we see if we knew nothing about these people? Most of the portraits were representative likenesses in which the subject adopted the role that he or she occupied in society, or at least hoped to occupy. It is much the same today. Roland Barthes wrote of the function of the (photographic) portrait something that we can also apply to Holbein and his paintings: "In front of the lens [or the artist] I am simultaneously the person I consider myself to be, the person I would like others to see me as, the person the photographer [artist] thinks I am and whom he avails himself of in order to demonstrate his skills." Although they were not the character studies which would later become customary, Holbein nonetheless succeeded in imbuing the protagonists of his time with personality.

Hans Holbein is well-known in Germany and popular in England. His portraits provide us with a better understanding of King Henry VIII's desperate search for a wife and queen. We can discern the extent to which his art was in demand over the centuries in a statement by the art historian Bernard Berenson from 1899: "[…] that no master artist, barely excluding even Raphael, was more difficult to secure, more in demand and had achieved comparably higher prices than Holbein".

A dispute concerning the portrait of Christina of Denmark also demonstrates Holbein's popularity. In 1909, there was an uproar among English society when the American collector Henry Clay Frick wanted to acquire the painting from the Duke of Norfolk and export it to the United States. The satirical magazine *Punch* thereupon published a caricature with the title "Hans across the Sea?", in which the wealthy American with a sack full of dollars was trying to kidnap the young Danish princess from the picture. The attempt failed, because the National Gallery in London succeeded in securing the painting from Frick. Although Holbein never became a British citizen, the British had taken the German-Swiss artist into their hearts.

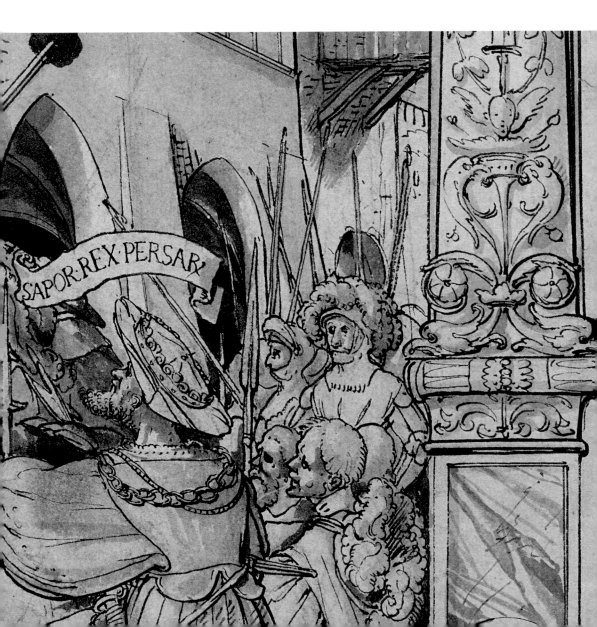

SAPOR·REX·PERSAR

From Augsburg to Basel

Hans Holbein the Younger was born into a family of artists in Augsburg during the winter of 1497/8. His father, Hans Holbein the Elder (c. 1460–1524), ran a successful artist's studio which participated in the creation of several large altarpieces, including the High Altar of Kaisheim Abbey (1502–1504) and the St Sebastian Altar (1516), which are on view (in part) in the Alte Pinakothek in Munich. Altarpieces demanded highly complex work processes and division of labour. Their actual painting itself was not in fact always the main focus but had to be brought into line with both the wood carvings and sculpture. The work of Hans Holbein the Elder lies at the threshold between late German Gothic art and the Italian influence of the Renaissance. His workshop was much in demand and was active not only in his hometown of Augsburg and in nearby Ulm, but also in Frankfurt am Main and in Alsace. His younger brother Sigmund (c. 1470-1540) was one of his assistants.

Like his elder brother Ambrosius (c. 1494–1519), the younger Hans (page 11) received a sound training in his father's workshop, and also became acquainted with the latest designs of the Italian Renaissance. On the one hand the most up-to-date architectural trends could be seen in Augsburg, the Fugger Chapel, for example, from 1509 and at the same time, in a workshop like Holbein's, there were also numerous engravings, collections of materials and sample books available, which were required for the execution of the diverse commissions. Moreover, Hans Holbein the

Self-Portrait, c. 1542/3

Elder was a sought-after portraitist and an enthusiastic illustrator; the portfolio of his surviving works is the largest among his contemporaries north of the Alps.

We do not know when the brothers Hans and Ambrosius set out on their traditional journeyman's travels, and where they went during that

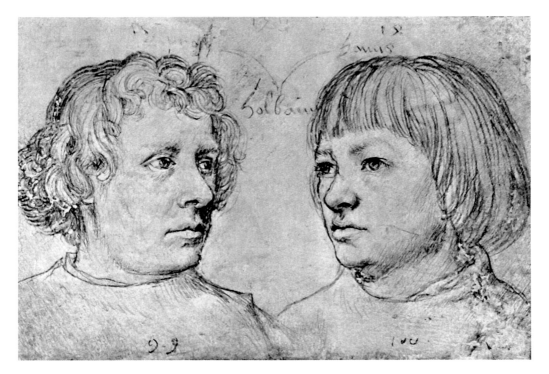

Hans Holbein the Elder, *The Sons of the Artist*, 1511

time. In any case, they arrived in Basel in 1515 and remained there. They had connections to the goldsmith Jörg Schweiger, who was also from Augsburg and who had already settled in Basel in 1507. He was the one to vouch for Ambrosius when the latter was accepted into the guild "zum Himmel" (literally: "of the skies" or "of Heaven") in

1517. Basel was a lively centre of the book trade; important printers and publishers had their main places of business there. It is interesting to note that Hans Holbein the Younger evidently made no attempt to offer his services to German cities or rulers. After he had moved to Basel, he never attempted to re-establish contact with his native

Julius Caesar with Antonius and Brutus, 1515

city of Augsburg. Nor did he refer particularly in his art to his German fellow artists like Albrecht Dürer (1471–1528), Lucas Cranach the Elder (1472–1553) or Albrecht Altdorfer (1480–1538). Only Hans Burgkmair (1473–1531) from Augsburg seems to have influenced him to some extent, especially with regard to profiting from his artistic experience from Italy (pages 40/41).

The Holbeins are certain to have known Albrecht Dürer, since Holbein the Elder also worked for the same clients, namely Maximilian I and Jakob Fugger. Moreover, in around 1509 Dürer's student Hans Schäufelein (c. 1480–1540) worked together with Hans Holbein the Elder in Augsburg. Dürer and Holbein also had something else in common, since the Nuremberg artist had worked as

a graphic artist in Basel in 1492, during his own time as a journeyman. Most of the illustrations for Sebastian Brant's *Ship of Fools* were made by him. In the works of Dürer and Burgkmair the Holbein brothers saw how drawings and prints could be turned to commercial advantage.

Their first commission came from the schoolmaster and Protestant reformer Oswald Geisshüsler, known as Myconius, who may also have taught them Latin. They were to decorate the borders of his edition of the *In Praise of Folly* by Erasmus of Rotterdam (c. 1467–1536) with their drawings. This was Hans Holbein's first (indirect) contact with the great Dutch scholar, whose work was an international sensation and is still printed today.

Hans Holbein created most of the illustrations, and indeed we can already recognise his remarkable talent for drawing as well as the interpretation of his subjects. In one drawing, the young Hans portrays his father, his brother and himself as Caesar, Mark Antony and Brutus (opposite). He depicts himself wearing the fool's cap, a character that he repeatedly introduces into his works.

The brothers also made the schoolmaster Myconius better known by painting a sign with text and pictures for him (page 13). Each of them painted one side, and here too we can see the difference in their skills. Ambrosius paints somewhat staidly, while Hans's work stands out in the way he records gestures, light and shadow, displaying a refinement superior to his brother's picture.

There are very few official biographical memoirs or notations about the two brothers, but they

Wer jemand hie der gern welt lernen dütsch schriben und läsen uß dem aller kürzisten grundt den jeman erdencken kan do durch ein jeder der vor nit ein büchstaben kan der mag kürtzlich und bald begriffen ein grundt Do durch er mag von jm selber lernen sin schuld uff schriben und läsen und wer es nit gelernnen kan so ungeschickt were Den will ich um nüt und verbgeben gelert haben und gantz nüt von jm zü lon nemen er syg wer er well burger Ouch handtwerckß gesellen frowen und junckfrouwen wer sin bedarff Der kum har jn der wirt drüwlich gelert um ein zimlichen lon Aber die jungen knaben und meitlin noch den fronuasten wie gewonheyt jst Anno m cccc xvi

Schoolmaster's Sign, 1516

were very probably journeymen in the workshop of Hans Herbst (1470–1532) when Hans Holbein received his first major commission in 1516. He was to paint the double portrait of the newly elected mayor Jakob Meyer zum Hasen and his wife Dorothea Kannengießer (pages 40/41). It is very surprising that the new mayor should entrust the project to such a young artist, who was neither a citizen of Basel nor a member of the relevant guild; nonetheless, the result proved that his decision was right. It seems, therefore, that word of the new "star" on Basel's art scene had got about at a very early stage.

After such a prestigious start, Hans Holbein doubtless expected to receive equivalent follow-up orders, but that did not turn out to be the case. Ambrosius was admitted to the guild in Basel in 1517 and acquired citizenship during the following

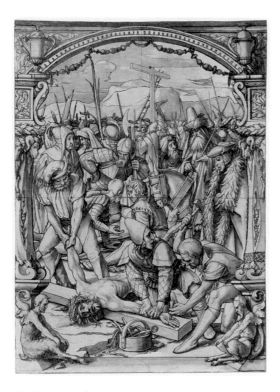

Windowpane draft, *Christ being Nailed to the Cross*, c. 1528

year. Hans, on the other hand, worked with his father in Lucerne between 1517 and 1519 on the decoration of the interior rooms and façade of the house of Jakob von Hertenstein, a merchant by profession and the so-called *Schultheiß*, a sort of head of city government. He also painted the portrait of von Hertenstein's son Benedict (pages 42/3).

It is possible that during his time in Lucerne, Hans Holbein travelled to nearby Milan and continued on to northern Italy in order to study the art there, which was dominated by Andrea Mantegna and Leonardo da Vinci at that time. We have no concrete proof, but it seems possible and would make sense. On the other hand, there is no trace

of Italian influence in Holbein's work during the subsequent period, in contrast to his journey to France, which left impressions that had a noticeable effect on his work.

Anyway, the Hertenstein house was demolished in 1825; a few subsequent drawings show interesting but conventional results compared with those of later works. This may have been due to the cooperation with his father, who had taken on the commission because his son was not authorised to do so. Hans Holbein the Elder had worked before and since in Isenheim in Alsace and died in 1524. Hans the Younger would most certainly have acquainted himself with the impressive *Isenheim Altar* by Matthias Grünewald (c. 1480–1530). Back in Basel, Hans also became a member of the guild "zum Himmel" in September 1519. No subsequent records of his brother Ambrosius have survived from this time onward, and it is assumed that he died that year.

Holbein tried his hand at a wide variety of fields, especially as an illustrator for woodcuts and as a designer of sketches for stained glass windows. Glass painting was one of the foremost prestigious genres in Swiss art during the sixteenth and seventeenth centuries. Parishes and cantons donated and exchanged the so-called city and cantonal windows. Entire cycles of glass painting were created for council chambers and banqueting halls, and also for private purposes. The artists who designed them, like Hans Holbein, and the glass painters were thus guaranteed an income of some degree. In addition to about eighty decorative border drawings for Myconius's *In Praise*

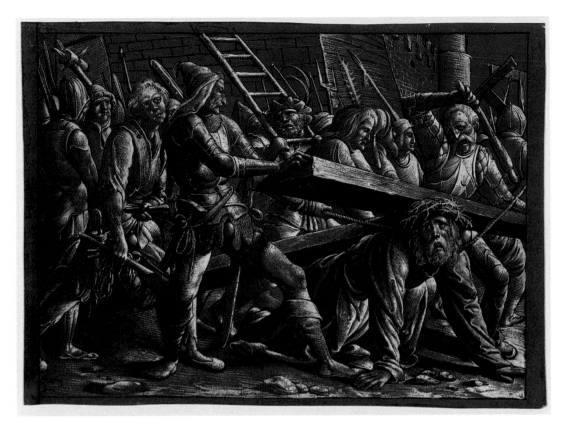

Christ Carrying the Cross, c. 1518

of Folly, a total of some 400 drawings by Holbein have survived, such as designs for book covers, glass painting, woodcuts, jewellery and various utensils like goblets and sheaths for daggers. And then there are a number of sheets which stand alone as works of illustrative art, especially from the short phase between 1518 and 1520, in which Holbein experimented with the chiaroscuro technique. With his portrait of Bonifacius Amerbach (pages 44/5) he established contact with the Humanist circles in Basel; he had acquired gratuitous citizenship in 1520 with his marriage to the widow Elsbeth Binzenstock (pages 80/81).

His rapid rise to becoming Basel's most employed artist had begun.

Holbein spent the year immediately after his return from Lucerne both effectively and successfully with his remarkable design for the façade of the house "Zum Tanz" in 1520 (pages 48/9). After that, in 1521, the young master was awarded the most important commission that the city of Basel had to offer at the time: the decoration of the new Great Council Chamber. Only a small number of much-overpainted fragments and preliminary drawings have survived today. As was frequently the case for commissions of this kind, the basic

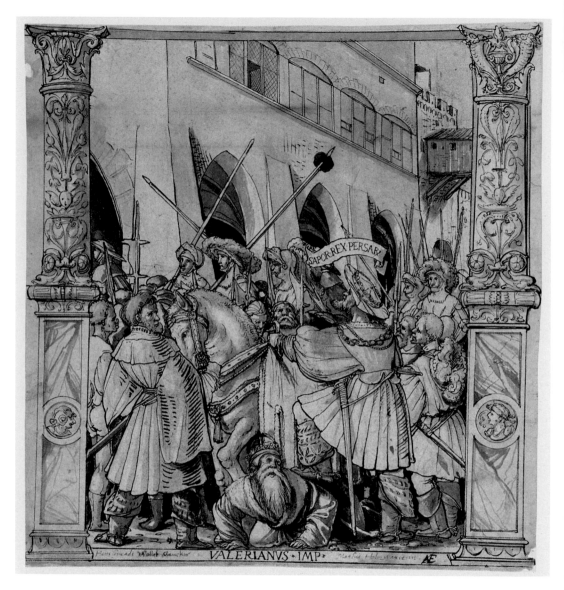

The Humiliation of Emperor Valerian by Shapur, King of the Persians, 1521

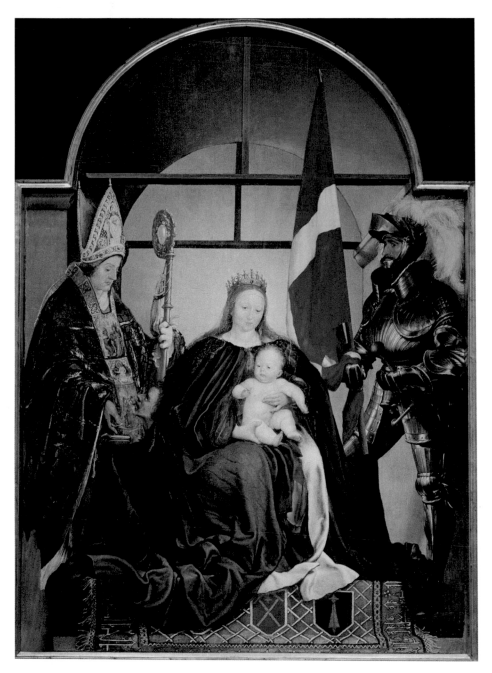

The Solothurn Madonna, 1522

Jeanne de Boulogne, Duchess of Berry, c. 1523/4

subject was the appeal for and consequences of good and bad government by means of examples from Antiquity and the Old Testament, such as *The Humiliation of Emperor Valerian by Shapur, King of the Persians* (page 16). Holbein was to paint three walls, and he received 120 guilders in payment in November 1522, although only two walls were finished. He did not complete the third wall until 1530, after returning from his first trip to England, for which he was paid another 60 guilders.

Holbein also completed a number of major religious commissions until the Reformation became too powerful in Basel. In 1521 he created the poignant *Body of the Dead Christ in the Tomb* (pages 52/3) and in 1522 the *Solothurn Madonna* (page 17), named after its present location, and commissioned by the Town Clerk of Basel, Johannes Gerster.

While he was still a journeyman, Holbein had been allotted tasks which would normally have been carried out by a master artist. In Basel he was fortunate that his clientele recognised his skills and fostered them, especially the mayor, Jakob Meyer zum Hasen, as well as Bonifacius Amerbach, who introduced the young artist to Humanist circles, and last but not least, Erasmus of Rotterdam. In the latter's case it is not quite clear whether he did in fact intentionally support Holbein, because his possible patronage mainly had something to do with Erasmus himself. The scholar worked independently and made use of his portraits to keep friends and (potential) patrons well-disposed and to ensure that they

remembered him by something apart from his writings. So Erasmus needed a talented painter who would propagate his image (and Erasmus was not lacking in vanity when it came to his painted self); the young Holbein for his part profited from the name and reputation of the scholar, who was known and highly esteemed throughout Europe. Erasmus also had his portrait painted by Quentin Massys (c. 1466–1530) in the Netherlands and by Albrecht Dürer in Nuremberg; he regarded the latter as the "new Apelles", in other words as the best contemporary artist. Erasmus valued quality and even as a young man Holbein was already the best portraitist, at least in Basel. In 1523 he painted Erasmus several times (pages 54/5 and 56/7) and thus created the image of the Dutch scholar which most people are familiar with today.

France

From the end of 1523 until the spring of 1526 there are noticeable gaps in Holbein's work and in the documents in Basel that mention his name; these are, in any case, few in number. Two drawings by Holbein himself can shed light on at least one of his locations during this period. In 1524 he drew the Duke and Duchess of Berry (page 18) in the chapel of the Ducal palace in Bourges, where the couple adorned their own tombs in the form of statues. Why Holbein drew the two monuments in such a lively manner becomes clearer when we read a letter which Erasmus of Rotterdam wrote in June 1524 to his friend Willibald Pirckheimer (1470–1530), an eminent Nuremberg Humanist

and friend of Albrecht Dürer: "I recently sent the Erasmus to England, painted twice by a very skilled artist. This same artist took a portrait of me with him to France. The King has again invited me to come to France." The King of France, François I, supported Erasmus and had long wanted to have him at his court. In the portrait that Holbein painted of Erasmus and to which the latter refers in his letter, he, Erasmus, is in the process of writing a commentary on St Mark's Gospel, which he dedicated to François I (pages 54/5). Thus the painting of the popular scholar represented an opportunity for Hans Holbein to approach the King himself and to present it as a sample of his art, in order to apply for commissions or even for a position at the French royal court. The drawings of the ducal couple in Bourges were intended as a further example of his skill, especially as they were relatives of the King, albeit dead for over a century. Holbein demonstrated how talented he was, not only in the likeness of the portraits but also in the way that he succeeded in making the cold stone come to life in his drawing; it was his interpretation of the story of Pygmalion.

It is impossible to say how far Holbein got at the French court with his application; in any case, he did not gain any commissions, let alone an official appointment. But the journey was not in vain, because it enabled him to acquaint himself in particular with the latest achievements in Italian painting. François I had brought Leonardo da Vinci to Amboise along with at least three of his paintings (*Mona Lisa*, *The Virgin and Child with Saint Anne* and *Saint John the Baptist*). They had a

profound impression on Holbein (pages 80/81), as did the paintings and technique of Andrea Solario, whose influence can clearly be seen in Holbein's *Laïs Corinthiaca* (pages 60/61) and the *Darmstadt Madonna* (pages 62/3).

What Holbein also brought back with him from his journey, and which would accompany him for the rest of his life, can be seen in the drawings of the Duke and Duchess of Berry, namely the technique of depicting a figure in a very lively and impressive manner using just a handful of coloured chalks. Paintings like *Laïs Corinthiaca* were created after his return home in Basel. But Holbein will have also painted or drawn in France too, because he would have had to finance his trip somehow. He probably had contact with a group of Franco-Flemish artists who concentrated mainly on book painting and illustration and whom art historians have given the improvised name "1520s Hours Workshop", referring to the books of hours which they illuminated. Holbein may have contributed some sketches and drawings for books, stained glass windows and lithographs such as those he was familiar with from Basel. In his cycle *Dance of Death* (page 21), which was created between 1524 and 1526, we can see a number of parallels to the works of French artists. However, it is not possible to ascertain who was the forerunner for whom. Furthermore, the so-called *Icones*, illustrations of the Old and New Testaments, may have been produced during this time. However, like the *Dance of Death*, they were not printed until 1538 in Lyon by Trechsel, who were originally publishers from Basel .

Der Ackerman.

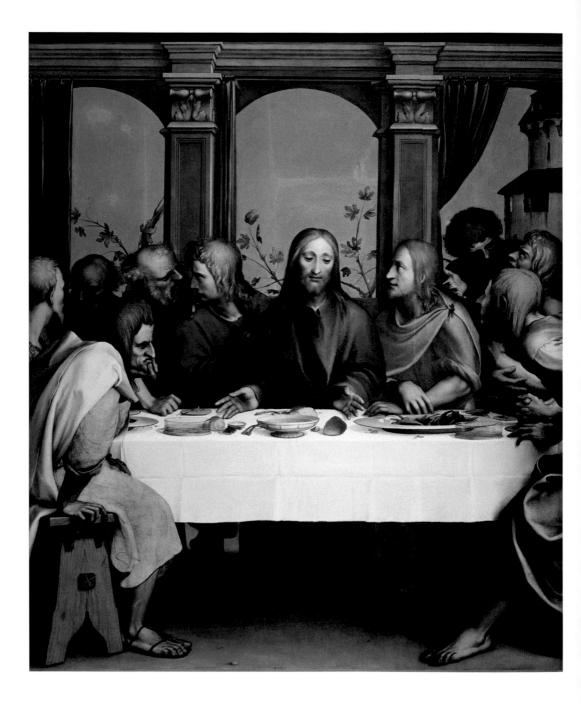

The Last Supper, c. 1527

Back in Basel I

Back in Basel, Holbein put his new experiences into practice, including, for example, the ultra-smooth, almost enamel-like treatment of surfaces which lends his paintings a particular sheen and character like those he had seen in the work of Andrea Solario. The brushstrokes are not visible and the transitions are flowing, but accurate, like Leonardo's *sfumato*—but clearer and without the smoky appearance characteristic of the latter's work. Holbein painted, amongst other works, his *Last Supper* (page 22) and *Laïs Corinthiaca* (pages 60/61). Perhaps he intended to make another later attempt at the French court with these new Italian-style paintings, since he sold neither of them.

The *Last Supper* is strongly reminiscent of the painting emerging from Leonardo and his circle. Did Holbein see drawings of the latter's *Last Supper* while he was there, or did he see the actual fresco in Milan, when he possibly travelled there from Lucerne? It is impossible to say, but the work was already so famous at the time that it was also widely available in the form of engravings and drawings. Nor can we say with certainty whether Holbein painted his *Last Supper* from 1527 entirely himself, or whether it was completed by his workshop without his help. We know from investigations that the underdrawing was drawn by Holbein himself—with his left hand. His *Last Supper*, as we see it today, is the much-restored remnant of what remained after the Protestant iconoclasm in Basel in 1528/9. Nine Apostles are

seated at the table with Jesus, and on the right is a pair of hands and a foot, belonging to a figure on the section of the picture that was cut off and has never been found. The panel was badly damaged, but at least it was not burned. Jesus's head was cut out with a saw, perhaps in order to safeguard it. Later everything was put back together again, so that the panel in the inventory of Basilius Amerbach dated 1585–1587 was described as follows: "Ein nachtmal vf holz mit olfarb H Holbein / Ist Zerhöwen vnd wider Zusammen geleimbt aber vnfletig" ("A supper on wood in oil paint by H. Holbein / Was smashed and glued together again, but badly executed"). In addition to the *Last Supper* the most important religious works during this period were the *Passion Altarpiece* (pages 58/9) and the *Darmstadt Madonna* (pages 62/3).

London I

Working conditions became increasingly difficult in the city of Basel, which was defined increasingly by the Reformation, because there was little demand for religious works. The Madonna which Jakob Meyer had ordered, remained an exception in this respect. She probably only survived this difficult time because either Meyer preserved the work in his own house, or it was in Holbein's workshop for revision. The hostility towards these religious images increased steadily, and many artists started to look for work in other cities. Holbein made a very bold decision. As the highly regarded young star of the Basel

art scene, he was greatly in demand and saw his opportunities abroad, with Erasmus of Rotterdam at his aid. Of course, Protestant regions were out of the question; we do not know who ultimately came up with the idea that Holbein should try his luck in England, but Erasmus had good contacts, including Thomas More, the author of *Utopia* and a resolute opponent of Martin Luther (1483–1546). More held high political office (pages 64/5), and was affiliated with William Warham, the Archbishop of Canterbury and Lord Chancellor of the King (pages 68/9).

Holbein's journey took him first to Antwerp. In his luggage he had a picture of Erasmus for William Warham and a letter from the Humanist to the publisher and town clerk of Antwerp Peter Gillis, known as Aegidius (1486–1533), who was a friend of both Erasmus and More: "The bearer is the artist who painted me. I will not bother you by recommending him, although he is an excellent artist. If he wishes to see Quentin (Massys), and you have no time to take him there, you can also get your servant to show him the house." Then he describes in greater detail the desolate situation of artists in Basel, because at the end Erasmus writes: "Here the arts are frozen; he is going to England to scrape together a few gold coins." It is noticeable that once again, Erasmus does not mention Holbein's name; for him, Holbein is a very capable craftsman but evidently not a partner on an equal footing, as he considered Albrecht Dürer to be. Holbein was a practical artist; he left no written records, no theories of art, no treatises on portraiture, no textbook. He 'only' drew and

painted; Erasmus, a man of words, evidently underestimated the qualities which characterise an artist like Holbein. He used artists and their works as perfect advertising campaigns for his own ends. How Holbein dealt with this attitude we can only deduce from the 'commentaries' that he painted into his pictures (pages 56/7).

After his arrival in England, Hans Holbein was taken into Thomas More's house. More wrote to Erasmus in December 1526: "Dearest Erasmus, your painter is a wonderful artist, but I fear he will not find England as fruitful and profitable as he hopes. However, I shall do my best to ensure that he does not find it quite so unfruitful." And that he did.

More's portrait followed, together with that of his family (pages 64/5 and 66/7), and Holbein's skills were very soon the talk of the town, as the portraits of the many important people in More's circle prove. A good example is Lord and Lady Guildford, whose portraits Holbein painted during this time. In the case of *Lady Mary Guildford* we can see the extent to which the close likeness of the preparatory drawing had to be modified for one intended for a courtly audience (pages 25 and 72/3).

The Swiss artist's repertoire included not only portraits, but also festival decorations. On the occasion of the celebrations marking the peace treaty between England and France in May 1527, the royal palace in Greenwich was appropriately decorated with "Master Hans" playing an important role. On the back of a triumphal arch he painted the Battle of Guinegate of 1513, which

Anna Meyer, c. 1525/6

the English had won, and the French then had to peruse once more as a pictorial taunt. On the ceiling he painted an allegory of the starry firmament with personifications of the planets and the signs of the zodiac. Here his adviser was the Munich court astronomer Nikolaus Kratzer, who had previously been the house tutor of the More family. He may also have helped Holbein linguistically, since we do not know the extent of the latter's knowledge of English (pages 76/7) Financially the trip to England had already been worthwhile at this point because he was by far the best-paid artist to work on the project. Sir Henry Guildford, the man responsible for the organisation of the celebration, could easily assess what Holbein's work was actually worth, since the artist had previously painted his portrait (pages 70/71). Unfortunately, none of the decorations have survived.

Holbein spent a total of almost two years in England. It was a very productive time. He created some twelve portraits and the group portrait of the More family, which was completely new for northern Europe, as well as the impressive portrait drawings and his work on the decorations for the festivities.

Back in Basel II

Hans Holbein returned to Basel during the summer of 1528. We know just how financially successful his time in England must have been because he purchased a house soon after his return, followed by the house next door in March 1531. It seems he had taken advantage of the opportunities presented

to him and now wanted to continue working in Basel again. However, the mood in the city had become yet more intense. The Reformation and its associated iconoclasm were now more widespread than ever. There was a "total freeze" on the arts, and for artists of Holbein's standing there was little left to do.

He changed the Madonna picture of the Meyer family whose daughter Anna in the meantime was now betrothed. Her hair, which she had been able to wear loose in the first version (page 26), was now tucked away under a traditional bonnet . He also made a few other changes to this masterpiece, especially to the head of Jakob Meyer's wife.

Holbein's paintings became highly sought-after collector's items within a short time after his death. In the 1630s, a French art dealer acquired the Meyer Madonna and had an exceptionally good copy made—albeit with recognisable differences in some details. He sold them both for exorbitant sums of money. The Madonna now circulated in two versions via various agents and purchasers throughout Europe and became one of his most famous pictures. One of the versions has been in Darmstadt since 1851, which explains the title *Darmstadt Madonna*, and the other version is in the Gemäldegalerie in Dresden. Since the route taken by the paintings was so circuitous it was no longer known which version was the original and which was the copy; accordingly, an exhibition was staged in Dresden in 1871, where the two pictures hung side by side. Hitherto, when the authenticity of a picture was

to be established, such assessments were based largely on intuition, the look-and-feel and on the changing ideals of beauty. Now more objective criteria such as the critique of style applied. The painting technique was examined and any visible changes, so-called *pentimenti*, were determined. Traces of this kind could be identified on the original, for example the hair of Anna Meyer, once loose but now painted over. Of course, the forger had not copied these changes which had previously been executed by Holbein, and so the authenticity of the *Darmstadt Madonna* could be determined. It was an important step for art history as a science.

In Basel, the Reformation progressed vigorously which had fatal consequences for art. In addition to the sale of indulgences in order to finance the rebuilding of St Peter's in Rome and the pomp of the clergy, one of the main points of criticism made by the Reformers concerned icondulism, the religious service to icons. A first iconoclasm had taken place as early as 1522 in Wittenberg, when all the pictures in the parish church had been forcibly removed. Luther in Wittenberg and Ulrich Zwingli (1484–1531) in Zürich had a more moderate attitude to icons, but they were not always able to assert their influence. Accordingly, iconoclastic riots occurred in many cities and churches, during which all of the art was destroyed. The same thing happened in Basel during Fasnacht (Carnival) in 1529. It was possible to save a few pictures, but it was clear that artists would not be able to live here anymore in the future. Erasmus von Rotterdam also left and moved to the Catholic Freiburg.

Most artists could no longer make a living. Some, like Urs Graf (1485–1528), became so-called Swiss mercenaries, soldiers for hire who entered the service of various warlords and created impressive depictions of war. Others, like Hans Herbst, the former master of Hans and Ambrosius Holbein, abandoned painting entirely. We do not know what Holbein's attitude to the Reformation was, but as an artist he can hardly have been in favour of it. He seems to have been fairly critical in his private life as well. In April 1530 he and a few of his acquaintants, including Hans Herbst, the goldsmith Jörg Schweiger, Hans Oberried (pages 50/51) and the publisher Johannes Froben received summonses because they had not taken part in the Reformed Lord's Supper. Holbein justified his action with words to the effect that they would have to explain the Lord's Supper to him more clearly before he would attend. The charge was not pursued any further; perhaps the "knights banneret" were not particularly strict, or perhaps his reputation as the best artist in the city protected him. Nonetheless, in this function he no longer had much to do. Holbein finished the third wall in the Great Council Chamber and created the organ wings in the Münster (pages 82/3). In October 1530, the City Council commissioned him to renew the painting and gilding of the two clocks on the Rheintor. What a task for an artist of his standing …

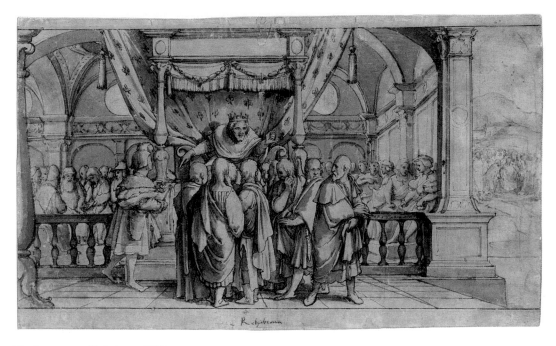

The Arrogance of Rehoboam, 1530

London II

Hans Holbein saw no future for his art in Basel when, in the spring of 1532, he set out for England once more. He left his wife and children behind. We do not know how long Holbein intended to stay in England on this occasion. On the other hand, we do know that the then mayor of Basel, Jakob Meyer zum Hirzen, sent Holbein a letter in September, in which he attempted to lure him back with an annual salary of 30 guilders and the prospect of earning more. The councillors were therefore well aware of Holbein's financial situation—and also realised whom the town was losing with his departure.

Holbein travelled first to Paris, where he was able to view Jean Clouet's *Portrait of King François I*, which evidently impressed him. Thereafter his route took him via Antwerp again. And this time, too, he had letters of recommendation from Erasmus, who, however, had written at the insistence of Bonifacius Amerbach and was evidently not particularly enamoured of the task, as we can gather from a letter to Amerbach from April 1533: "You push yourself forward as patron, the only person whom I can refuse nothing—as you well know. So, through you, Holbein has blackmailed me into writing him letters for England. And then he sat in Antwerp for over a month, and he would have remained there for longer if he had found some fools. In England he fooled those to whom he had been recommended."

We cannot explain for certain why Erasmus was so angry with Holbein; it must have had something to do with Holbein's attitude to religion and work. As the summons served on him

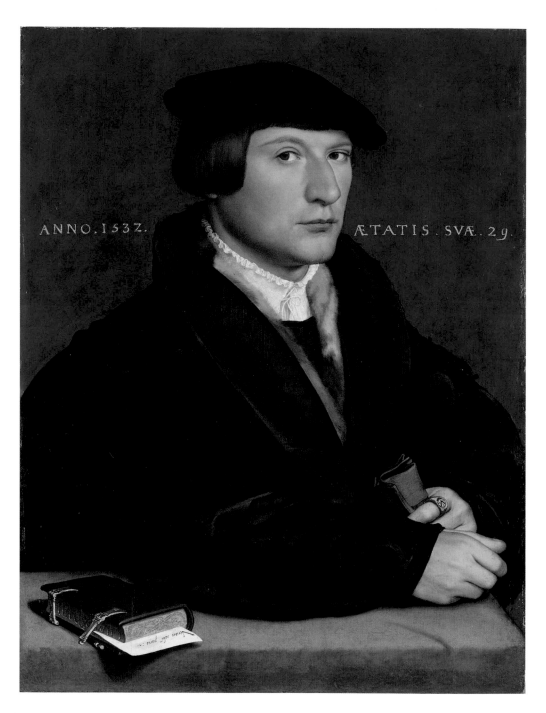

ANNO.1532. ÆTATIS.SVÆ.29.

Hermann von Wedigh III., 1532

in Basel indicates, Holbein was no supporter of the Reformation. He never openly committed himself to one side or the other, but instead worked for both the City of Basel, which had acknowledged the Reformation, as well as for the friends of Thomas More in England. Now the tide had turned, because Holbein's connections during his first sojourn in England no longer existed or were no longer helpful. William Warham and Henry Guildford had died in 1532. Since Henry VIII wanted a divorce from Catherine of Aragon, to be able to marry Anne Boleyn, he had broken with the Roman Catholic Church. So as not to find himself in conflict with the Vatican because of Henry VIII's Act of Supremacy, which made the King the Head of the Church in England, Thomas More resigned from his position as Lord Chancellor in May 1532 and was executed in 1535. New protagonists had entered the state and Holbein had to establish his position with them. He had succeeded to some extent in Basel but matters here in England were rather more volatile and heads were more likely to roll.

Holbein had to tap new sources of income. He found one in the branch of the German Hanseatic League, the so-called "Steelyard" by the River Thames. Here he painted portraits of the successful merchants and depicted them in the manner they wished: magnificent and full of detail in the case of Georg Gisze (pages 84/5), and Hanseatic and reserved like Derich Born (pages 88/9 and Hermann von Wedigh III. (page 30). The Latin motto on a note in his book derives from a comedy by Terence, the poet of Antiquity, and means

"Truth generates hatred". It could be a hint as to the book's contents but could also be the personal motto of Hermann Wedigh. In conjunction with his gaze, the latter interpretation would be somewhat strange.

The more modest-looking portraits of the merchants are particularly impressive because Holbein was able to demonstrate his skill in character drawing with no further frippery. The dates written horizontally in the background give the portrait-format pictures strength and a hint of nobility. Almost all the "Steelyard" portraits, of which seven have survived, bear this type of dating. Holbein also used this element as a kind of trademark in later portraits of various courtiers.

Hans Holbein's art was well received by the merchants, as can be judged not only by the large number of portraits made, but also in the merchants request that for the coronation of Anne Boleyn on 1 June 1533 he should design a festival decoration that would pay homage to the new Queen and therefore also to her husband. We do not know whether some of the merchants had already seen Holbein's festive decoration in 1527 in Greenwich. At that time, Holbein had designed a grandstand which showed Parnassus with Apollo under a canopy, surrounded by his Muses. Judging by the guests' reports, what impressed and delighted them most was the built-in fountain and the real Rhine wine which flowed freely from it.

Thereafter Holbein was granted the largest commission which the Hanseatic merchants were able to award: he was to execute two monumental paintings in their Assembly Room. The subject was

the "Triumph of Wealth" and its ambivalent counterpart, the "Triumph of Poverty". These works have also not survived and are only known due to drawings by Holbein himself as well as subsequent drawings by other artists. Karel van Mander (1548–1606), whose *Schilder-boeck,* published in 1604, contained the first artists' biographies north of the Alps, reported of the Italian artist Federico Zuccari's enthusiasm (1540–1609), who copied the murals for his own use: "these works are so good and so well executed as if Raphael da Urbino had made them." With the help of Holbein's drawing of *The Triumph of Wealth* (page 33) we can understand his rapture. Plutus, the god of wealth, is shown as an old man on a chariot drawn by four horses and accompanied by allegories of all kinds. Behind the triumphal carriage follows Nemesis, the goddess of poetic justice and revenge, under whose cloud Cleopatra, Midas, Tantalus and others are promenading; their fate is intended to show the vicissitudes of fortune. *The Triumph of Poverty* depicts equally the fickleness of Fate, the fear of collapse for the rich and the fearlessness of the poor who, because they possess nothing, can serve God virtuously.

Things were going well for Hans Holbein in London. Of course, his presence did not go unnoticed at court; he was not unknown as an artist because of his previous visit. And the painter from Basel took advantage of the opportunities that presented themselves. In 1533, he created what is today his most popular work and it was also one of his most elaborate: *The Ambassadors* (pages 90/91). It is possible, however, that the

time and effort he put in was not due only to the expectations of the client—Jean de Dinteville, the ambassador of King François I of France. It may also have been because the artist himself wanted to impress not only the subject and the public in London with this work and the equally remarkable portrait of Charles de Solier (pages 92/3). He was also targeting the French king and hoped that he would be granted an opportunity to submit an application again with these masterpieces, especially as François I was considered to be considerably more art-loving than Henry VIII. Moreover, France and especially Paris was Catholic and therefore more open-minded towards artists like Holbein. And François I had also summoned Leonardo da Vinci to France and was in the process of having his residence in Fontainebleau decorated by Italian artists including Rosso Fiorentino, Benvenuto Cellini and Francesco Primaticcio. This would result in the so-called "School of Fontainebleau", which would long exert an influence on French art. However, when Jean de Dinteville returned to France in 1534, he took *The Ambassadors* to his ancestral seat in Polisy, which is also marked on the globe in the picture. He also fell out of favour, and King François I never actually saw the painting.

At the royal court in London, Holbein succeeded in establishing new contacts and thus acquired new commissions. He advanced right into the centre of power with his portrait of Thomas Cromwell (pages 86/7), at that time Chancellor of the Exchequer and the King's confidant. It is not clear exactly when Holbein was granted the

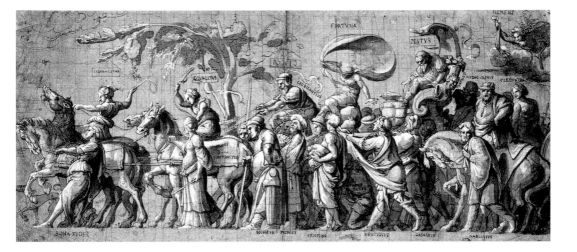

official title of "King's Painter," since the financial ledgers from 1532–1537 no longer exist, but when he drew the portrait of Anne Boleyn (c. 1501–1536) he would have already achieved the title and the corresponding salary. He worked not only as a portraitist, but also as a jewellery designer for the royal goldsmiths. Jane Seymour (c. 1509–1537), the successor to Anne Boleyn on the throne and at Henry's side, is certain to have worn jewellery which Holbein had created (page 35).

Of course, Holbein's principal task as the King's Painter was to present the monarch in a favourable light and thereby to cultivate his image (pages 98/9). The most important work was the monumental mural in the Palace of Whitehall, which can be regarded as the family tree of the new Tudor dynasty. A seventeenth-century copy of the work still exists (page 36). The inscription on the central pedestal in the manner of an epitaph is a eulogy to the Tudor men, to Henry VIII and his father Henry VII, as well as to his mother Elizabeth of York and Henry's third wife, Jane Seymour. Whitehall burned down in 1698 and so only a cartoon by Holbein himself has survived; it served to transfer the preliminary drawing onto

the wall (page 37). The drawing is over two and a half metres high and enables us to imagine the impressive size of this dynastic manifesto. The pose of Henry VIII is the one which we associate with him to this day: standing with his legs apart, with his massive body which appears even more powerful and potent because of the clothing. It is not exactly a courtly pose, but rather that of a hero who aims to radiate power and strength. The heroic portrait is also emphasised by the architecture, but Holbein would not have been true to himself if he had not dared to build in a certain rupture even here. He reveals that the imposing triumphal architecture is a mere stage prop by pushing it in front of the actual room architecture, which we can see in the overlapping reliefs at the base of the column between the king's calves. A subtle questioning of the heroic presentation.

The overall composition with the figures positioned around the centre recalls *The Ambassadors* but is also reminiscent of Holbein's work as a book illustrator, because it is also a variation of different title pages he had designed. Here once again the artist's highly economical working approach shines through, in which he adopts successful

solutions and adapts them correspondingly. And thus, he succeeds in developing a monumental portrait of a ruler by way of small-format book titles.

Basel Intermezzo 1538

One of the tasks for which Hans Holbein became famous was as the portraitist of the possible future brides of Henry VIII and as such, the future Queens of England. To this end he travelled on several occasions from London across the English Channel in 1537 and 1538 in order to paint Christina of Denmark in Brussels (pages 100/101), Luise von Guise in Joinville and Anna of Lorraine in Nancy, so that the King could decide on his new Queen. Of course, the political circumstances and considerations were important and decisive in each case, and for these Thomas Cromwell as Lord Chancellor was chiefly responsible. Holbein could only do his best regarding the visual aspects, which he evidently overdid in 1539 in the case of Anne of Cleves (pages 102/3). Henry married Anne by proxy and regretted the decision the very moment she stood before him. This had far-reaching consequences for Thomas Cromwell, who was beheaded because of it a short while later. Holbein got off lightly, perhaps because Henry was absolutely convinced of Holbein's skill despite this faux pas and was well aware of his competence and expertise. This can be seen in a witticism that Karel van Mander reported after an Earl had complained to the King about Holbein. Henry VIII explained to the nobleman that if he

wanted to, he could easily make seven peasants into seven earls, but it would be impossible for him to turn seven earls into just one single Holbein.

In September 1538, Holbein returned to his hometown once more. As already mentioned, he had painted the portrait of Anna of Lorraine in Nancy as part of the search for a new wife for Henry VIII. While he was there, he made a long-planned detour to Basel. It was long-planned, because that May Holbein had already been granted an export licence for "600 tuns [barrels] of beer", which he had no doubt intended his family to sell, since the export of money from England was prohibited.

But that was not the only deal that the artist had arranged in advance; there was also a possible new agreement with the City of Basel. On 16 October, Holbein signed a remarkable contract which guaranteed him an annual salary of 50 guilders for the rest of his life. The authorities responsible in Basel had, in the meantime, apparently recognised Holbein's worth. They gave him two years' grace to complete his works and other affairs at the English court and granted his wife in Basel 40 guilders per year during the interim. And because the Swiss realised that they had too few commissions for a painter of Holbein's standing, each of these commissions was to be paid for separately, and he was entitled to accept others from "foreign kings, princes, lords and cities" and to receive a salary. In addition, he could send these and other works which he created in Basel abroad two to three times a year or sell them there, whereby "abroad" was clearly defined: France, England, Milan and the Netherlands. Holbein had

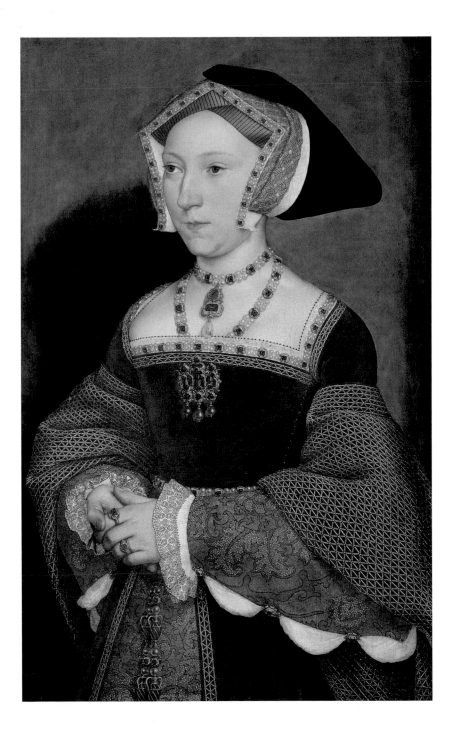

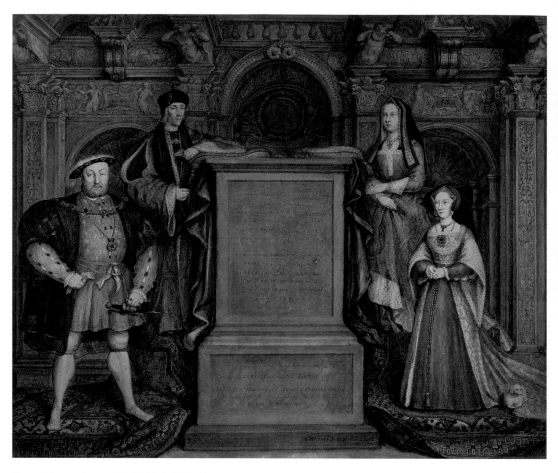

George Vertue, *Copy of The Whitehall Mural*, 1737

special relationships with these places or already had promising commissions, otherwise he would not have had them listed in the contract. In addition, he was also granted the possibility to trade and sell uncommissioned works at fairs, as Albrecht Dürer and Lucas Cranach had already been doing for some time.

This contract guaranteed Holbein's economic security, even if conditions in England should develop in the wrong direction—they were difficult in any case. He returned there in October 1538 and never went back to Basel. We do not know why he remained in England after the two years had elapsed. Had he risen in favour at court? That seems unlikely since he acquired no more portrait commissions from the King after the incident concerning Anne of Cleves' picture. Was he nonetheless able to improve his position there by using the contract as a basis for negotiation? Or were the reasons personal? As we can learn

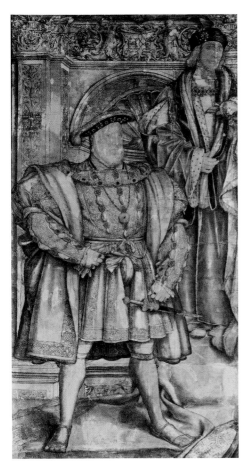

King Henry VIII and his Father King Henry VII, 1537

from his will, he had two children in London, for whose upkeep he made arrangements—and perhaps there was also a woman involved. On his self-portrait, created in 1543, he described himself as "BASILEENSIS". Hans Holbein died, probably of the plague, in the autumn of 1543 at the age of about 45.

Hans Holbein the Younger is an artist whose work becomes increasingly fascinating with regard both to painting technique and content, the more we examine the details and the references. He created an oeuvre based on principles of high efficiency and economic working processes, linked with outstanding skill and a subtle sense of humour. He never explained his art in written texts, nor did he draw up theories relating to his approach. Everything which seemed important to him in his art, from the earnest to the dramatic, and from the elegant to the critical and humorous, is taking cover in his pictures for all the world to see.

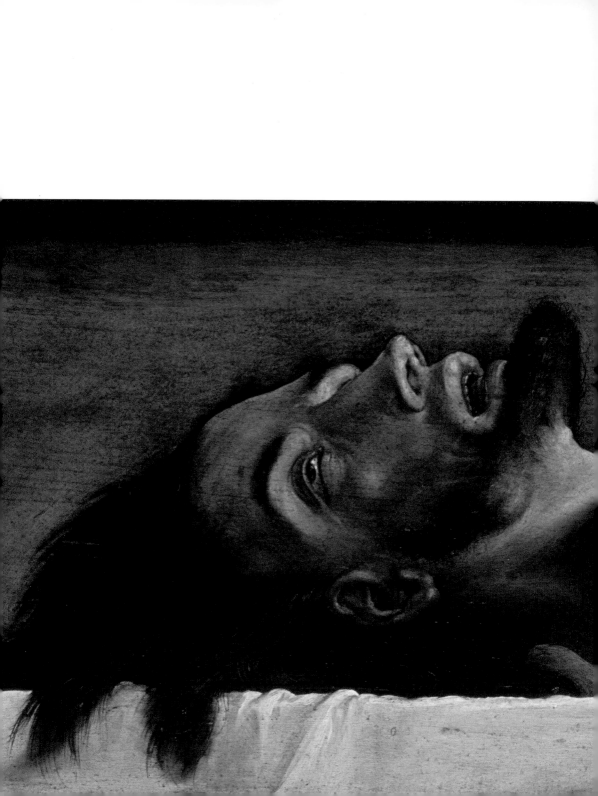

WORKS

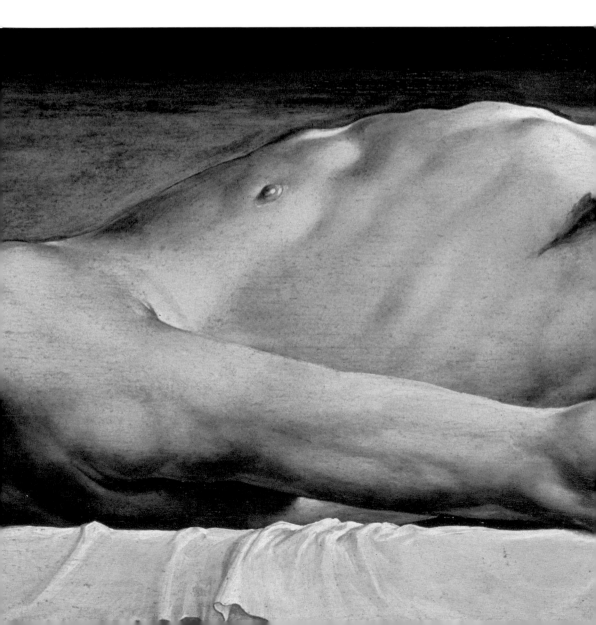

Jakob Meyer zum Hasen and his Wife Dorothea Kannengießer, 1516

Oil on lime wood
Diptych, each panel 38.5 × 31 cm
Kunstmuseum Basel

We shall never discover why the recently elected mayor Jakob Meyer (1482–1531) commissioned a painter's journeyman who was not even 20 years old at the time with a double portrait of himself with his wife. It cannot have been because he could not afford to pay the fees of a master artist; Meyer had acquired considerable wealth as a money changer, property agent, publisher, merchant and not least as a military leader, as can be clearly seen in this double portrait. He is quite casually dressed, but the rings on his fingers and his wife's gold embroidery and jewellery speak for themselves. The coin he is holding points on the one hand to his profession as money changer, but also refers to the fact that the emperor had recently granted Basel the right to mint its own gold coins, which no doubt suited Meyer's business interests as well. But perhaps Meyer could also put himself into Holbein's shoes—after all, he was the first mayor who was neither a patrician nor a nobleman, but whose origins lay in the city's guilds.

Holbein prepared the painting in the way his father had taught him, with two drawings in silverpoint and red chalk, in original size, a practice he would continue with for most of his portraits. Holbein copied the idea of an elaborately decorated Renaissance arch extending across both panels above the heads of the husband and wife from a portrait woodcut from 1512 by his older Augsburg colleague Hans Burgkmair, which he must have known from his home country. As always in the case of his role models, here too Holbein succeeded in developing the idea and improving on it. While Burgkmair's arch was a purely honorific formula, here it acquires an additional function: it creates the space in which the figures are embedded. Although they have both leant their arms onto the edge of the picture— another device which unites them—their positions within the space and hence their relationship to each other are only defined by the slanting angle of the architecture. Meyer has a far-sightedness of vision as he calls attention to his wife, while she seems to have moved away, gazing graciously at her husband.

The young Holbein evidently put considerable effort into this double portrait— successfully, as it granted him access to the élite of Basel and hence to a large number of new commissions. He consequently placed his initials "HH" and the year of creation, "1516", in the frieze above his client.

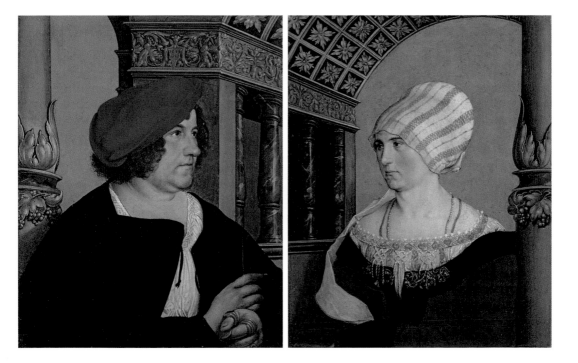

Benedikt von Hertenstein, 1517

Oil and gold on paper, glued onto wood
52.4 × 38.1 cm
The Metropolitan Museum of Art, New York

"Then I had the figure, I was 22 years old", is the comment on the wall beside Benedikt von Hertenstein (1495–1522). He had his portrait painted in Lucerne in 1517 by Hans Holbein, who was just two years his junior. The latter signed the picture with "1517 HH PINGEBAT". The occasion for the portrait will have been Hertenstein's appointment to the Great Council of the City of Lucerne. The fact that Hans Holbein painted Benedikt in his hometown was due to the commission that he was executing at that time in Lucerne together with his father and possibly also his brother Ambrosius, namely the design of the façade and interior of the Hertensteins' house.

Jakob von Hertenstein, the subject's father, was a wealthy man, an important merchant and the *Schultheiß*, a sort of head of government of the City of Lucerne. This can clearly be seen in his son's clothing. He is sumptuously dressed, with an imposing gold chain and six rings on his left hand, which is resting in a more or less casual manner on the ornately decorated hilt of a dagger. The young man is gazing rather shyly and uncertainly at the viewer. Holbein has placed him in a corner where the back wall is not at a right angle to the wall on the left. This is interesting because it seems to change when looking at the picture from further to the right, in which case Benedikt's eyes follow the viewer. As a result of the lighting direction, which darkens the wall on the left and casts the subject's strong shadow onto the back wall, the young man appears to emerge three-dimensionally from the corner of the room. Above him is a frieze with a triumphal procession as a *trompe-l'oeil* low relief, which is intended to add a further aristocratic element to the portrait of the rich man's son. In this illusionistic detail Holbein has made an early attempt at the so-called "paragone", the contest between painting and sculpture. The role model for the procession was the series of the *Triumphs of Caesar*, which Andrea Mantegna (1431–1506) painted on nine panels for the Duke of Gonzaga in Mantua. Holbein probably knew the work from engravings, which were widely available in artist's circles. Even here, as ever, Holbein has treated his reference very freely and used it as a basis for his own work, by combining the individual scenes to create a continuous image and by introducing new figures. What is noticeable in Holbein's triumphal procession is that the triumphal hero is missing. He ought to follow at the far right, but his absence is probably due to the fact that at this time Mantegna's procession had not yet been published in its entirety.

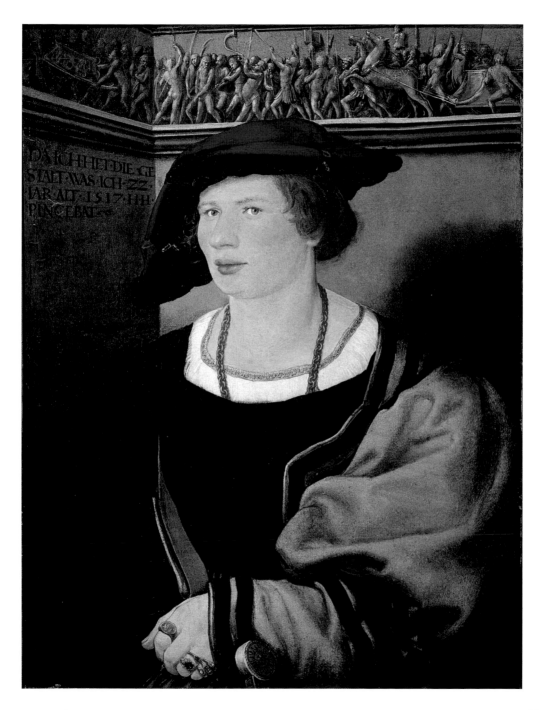

43

Bonifacius Amerbach, 1519

Mixed technique on fir wood
29.9 × 28.3 cm
Kunstmuseum Basel

To mark his 24th birthday, Bonifacius Amerbach (1495–1562) had his portrait painted
by Hans Holbein. This was the first major commission which Holbein took on as an
independent master artist; he had just been accepted the previous month into the
guild "zum Himmel". This delicately worked portrait enabled Holbein at the latest
to gain access to and recognition from the Humanist circles in Basel, because
Amerbach was the son of one of the pioneers of printing and publishing in Basel and
had been a close friend of Erasmus of Rotterdam since his student days in Freiburg.
Amerbach studied the theory of music, classical languages and law.
Holbein shows the scholar, who was almost the same age as himself, in a triangular
composition reminiscent of the busts of Antiquity, with his head at a three-quarters
profile. The background of this almost square-format picture shows an evidently
expansive landscape with snow-covered mountains and it was the only time that
Holbein used this feature in his entire oeuvre. The composition is framed by the
fig tree on the left-hand side and one of its branches on the right. In addition to
Bonifacius himself, the most noticeable feature is the panel hanging on one of the
branches. On it the picture sings the praises of the likeness with a Latin couplet:
"Although a painted face, I am not inferior to the living one, I resemble the master,
outstanding with the correct lines [...]." Amerbach wrote it himself after many
attempts and corrections. It aims to emphasise his literary education and to give
the picture something that paintings inevitably lack: a voice, with which one's own
mental image could come into being.
The panel is dated 14 October 1519, which in this case does not refer to the creation
of the portrait, but to Amerbach's birthday. This may have been the reason for the
portrait's commission, or another may have been his studies, which he had hoped
to pursue from 1520 onwards in Avignon. Hence also perhaps the snow-covered
mountains, which the subsequent law professor and universal heir of Erasmus of
Rotterdam would have to cross to get there. The landscape is presented as so open
and cheerful that this seems not to have posed a major problem.
We know from Amerbach's records which have survived that he had planned a
second portrait without a beard, as a sign of his abandonment of outer appearances
and a new beginning. Unfortunately the picture was never realised.

PICTA LICET FACIES. VI
VAE NON CEDO. SED INSTAR
SVM DOMINI IVSTIS NO
BILE LINEOLIS :❦:
OCTO IS DVM PERAGIT
TPIETH, SIC GNAVITER IN ME
ID QVOD NATVRAE EST,
EXPRIMIT ARTIS OPVS.

BON. AMORBACCHIVM.
IO. HOLBEIN. DEPINGEBAT.
A. M·D·XIX· PRID. EID. OCTEB.

The Pensive Christ and the Virgin Mary Grieving, c. 1518–1520

Oil on lime wood
Two panels, each 29 × 19.5 cm
Kunstmuseum Basel

Hans Holbein presents us here with a masterfully executed scene from the Passion which is not described in the Gospels. It is a contemplative moment, a brief interlude between the crowning with the Crown of Thorns and the Scourging. Christ is wearing the Crown of Thorns, but his body does not yet bear the traces of torture. A more usual devotional picture would have been the so-called "Ecce Homo", in which Christ is shown with all the signs of torture and crucifixion, but still alive and not on the Cross. Holbein's scene is an unusual one, but one that was also portrayed by his father.

The right-hand panel shows the Virgin Mary who, as in pictures of the Annunciation, appears to have been caught unawares in prayer and who has turned towards Jesus. The latter appears to be exhausted rather than overcome by pain, and to be disillusioned by the human race and his death. He knows what will happen and seems resigned to his fate. The scene takes place in a remarkable architectural setting which looks like a stage. Christ is seated on the pedestal of a loggia supported by two pillars above an irregular ground plan. There is a sort of architectural decoration which is further emphasised by the festoons on the ceiling. The two paintings are executed in monochrome shades of ochre with white highlights which are applied so thinly that the underdrawing beneath is still visible to a large extent. This makes the two panels look more like drawings than paintings. The festoons provide the only colour contrast; they were originally green and have become brownish over the years; furthermore, the sky which can be seen through the architectural structure is turquoise blue.

If we look more closely, we notice the subtle differences between the panels. The right-hand one seems marginally less full of contrasts, while the left-hand one appears more accentuated, as we can see, for example, in the white highlights. The cornice above the middle arcade seems not to quite fit, and also there are three obvious corrections to the plinth and the two steps on which Christ is resting. Their perspectival alignment was changed using white paint, thereby shifting the central point of the left-hand picture to the right and into the middle, between the two panels. The panel depicting Christ could easily stand on its own, especially without these corrections. Perhaps Holbein painted the left-hand panel first (1518) and later expanded it by the second one (1520) to form a little devotional altar. The noteworthy and highly fanciful architecture which Holbein created from 1520 on the façade of the house "Zum Tanz" (pages 48/9) would seem to fit this theory.

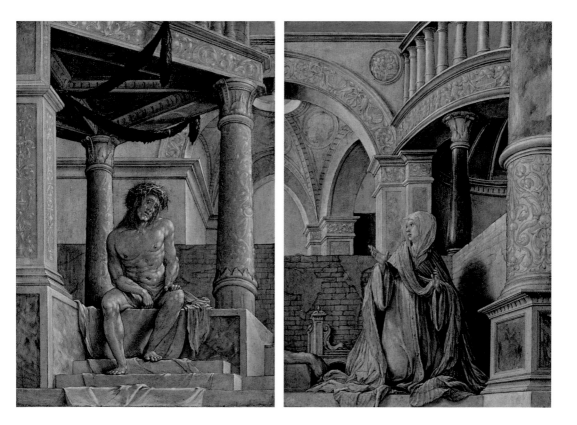

Design for a façade painting on the house "Zum Tanz" in Basel, overlooking Tanzgässlein, c. 1525–1530

Pen and black ink, painted in watercolours, composed of
four sheets, mounted on thin paper
62.2 × 58.5 cm (sheet)
Kunstmuseum Basel, Kupferstichkabinett

In his early years, when he had not yet become the portraitist of the "rich and famous", Holbein created a wide variety of works. The largest, such as the façade painting for the house "Zum Tanz" from 1520, have unfortunately not survived. By the end of the eighteenth century the painting had been badly damaged, and the house on the corner of Eisengasse and Tanzgässlein—hence the house's unusual name—was later demolished, so that today only two drawings from Holbein's workshop survive, enabling us to admire the remarkable design.

In the decorative border drawings for *In Praise of Folly* (page 12), Holbein drew himself as a young man wearing a jester's hat, Here we can see how he perhaps intended that. In this façade design, which he created for the goldsmith Balthasar Angelrot, the artist has allowed himself the liberties which a young fool would be entitled to—albeit linked with an overwhelming sense of imagination and an equal degree of skill. The real house is clad with illusionistic architecture, thereby creating a palace contradicting every architectural rule. Colonnades alternate with arcades, arches and balustrades, surge backwards and forwards and open up spaces where actually there are none. The building appears not to have been finished, as at the top unplastered, brick walls are still visible. And then there are the people who bring this world to life: a few inhabitants, peasants dancing around the house, and soldiers. One of them even seems to want to leap downwards onto his horse, thereby alarming his comrade standing below. Slinking in to join the stout Bacchus on the first floor is a rather plump cat with a mouse, while below a rider is looking fearfully at his horse out of the corner of his eye.

Holbein's work on the Hertenstein house in Lucerne was still largely conventional, which may possibly have been due to his partnership with his father. Here, by contrast, he sparks a firework display of ideas which humorously abandon the structural logic of the architecture. The work of the young master painter, who had only been accepted into the guild the previous year, was evidently regarded as very good, otherwise he would most certainly not have been entrusted during the following year with the most important commission that Basel had to offer, namely the painting of the big new council chamber.

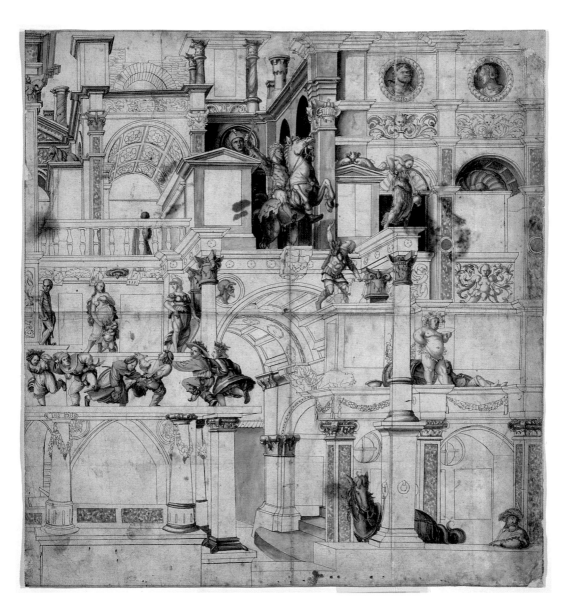

49

Oberried Altar, c. 1520 (?)

The Nativity of Christ (left), The Adoration of the Magi (right)
Oil on conifer wood
Each panel 230 × 109 cm
Freiburg Minster, University Chapel

There are many unanswered questions regarding the two altar wings which Hans Holbein created. If these are the side wings of an altar, what would the central panel have been like? Would it have been a Madonna? Would it have been a painted or a carved altar? And what would the links to the central picture have looked like? All these questions cannot be answered, and nor can the question as to exactly when the wings were painted.

The two scenes, the Nativity and Adoration of Jesus, both take place on a sort of stage, in front of which the donor, Hans Oberried the Elder, and members of his family, are shown kneeling. Oberried, a native of Freiburg, had been a citizen of Basel since 1492 and was appointed to the Town Council in 1512, as was repeatedly confirmed until February 1529. Nonetheless, after so many years he relinquished his rights as a citizen just a month after his last call, because Basel had joined the Reformation and the Catholic Oberried felt he was unable to remain any longer. He returned to Freiburg and took the two altar wings with him. This move is probably the reason why the portraits of the donor family, with the exception of Oberried himself, whom Holbein himself painted, were executed in Freiburg by another artist of considerably inferior quality.

Holbein stages the nativity of Christ on the left on a raised stage with theatrical architecture. The infant's divine radiance illuminates the scene. As so often when Holbein depicts architecture, it is both impressive and illogical. This also applies here: a column rises at front right; its base lies in the area of the donor and the pious onlookers, while on the left-hand side, in the world of the saints, a pillar rises with an arch extending above it, apparently linking it with the pillar on the right. We can make out a pregnant figure on the pillar which could be interpreted as Eve, who because of the Fall from Grace "brought forth children in sorrow", while the Virgin Mary gave birth to Jesus painlessly and so revoked Eve's guilt. This corresponds with the ruin architecture in the right-hand picture, whose decay symbolises the pre-Christian world which was replaced by Jesus and the New Covenant.

In these altar pictures the young Holbein developed several references to German, Dutch and Italian art. The overall design with the steep alignment of the architectural perspective derives from a drawing by his father, for which the latter in turn had borrowed references from the Netherlands. The angels with their eye-catching feathered arms come from Hans Baldung Grien (who also created the High Altar in Freiburg Minster dating from 1512–1516), and the "godfather" of the greyhound was the corresponding animal in Albrecht Dürer's famous engraving *Saint Eustace* (c. 1501). We can find numerous quotations, adaptations and resemblances on these panels, which Holbein masterfully made his own in a truly unique manner.

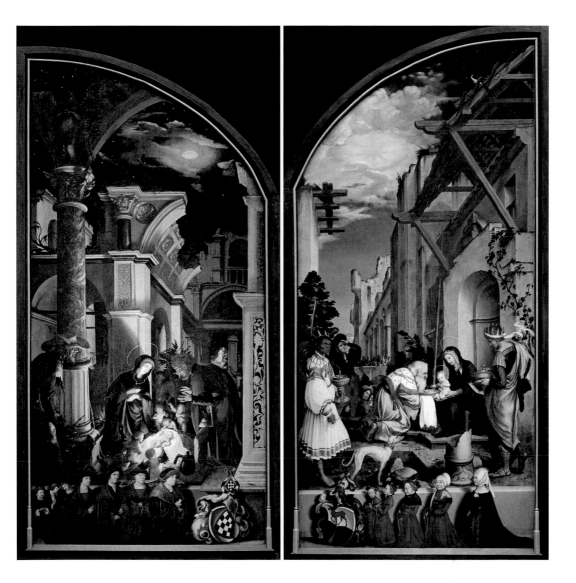

The Body of the Dead Christ in the Tomb 1521/2

Oil on lime wood
30.5 × 200 cm
Kunstmuseum Basel

Painted in 1521, this is one of the most important and impressive works by Hans Holbein. He is the only artist to portray the dead Christ lying in his tomb. All other artists show Christ at the Entombment or Resurrection. Holbein's tomb does not resemble the rocky cave which he portrays in the *Passion Altar* (pages 58/9) or the stone sarcophagi of other painters, but rather recalls the Roman catacombs, in the niches of which the corpses were laid.

The body can only be identified as the crucified Christ by the wounds in his side, hand and feet. Holbein probably knew the dramatic altarpiece portrayal of the body maltreated by scourging and crucifixion by Matthias Grünewald in nearby Isenheim (1512–1516). In order to heighten the dramatic effect, Holbein did not add still more injuries, but painted the dead body in a highly realistic manner. Nothing is more harrowing than comprehensible reality. We see a dead body which stiffened in pain, and judging by the greenish colour of the skin on his head and around the wounds, seems to be in the early stages of decomposition. The mouth and eyes are slightly open, as if the dead man had been denied the final act of mercy in closing them. Such macabre depictions of the sufferings of Christ were not uncommon at the time. In the case of Passion scenes in particular they were expected, because the more intense the feelings of compassion, *compassio*, they aroused, the greater the salvific effect. And Holbein pursued this to extremes in the highly realistic portrayal of a lonely corpse within the confines of a tomb.

We can also read Holbein's *Dead Christ* quite differently, however. If we study the picture for some time, we notice the tension in the body. This is not a corpse that has become flaccid in death. All the muscles and tendons seem to be tense. The mouth and eyes are slightly open, not because people refused to close them (why should Joseph of Arimathea, who buried him, have done that?), but because Holbein has shown the moment in which Christ's Resurrection begins. The body seems to draw breath and summon up fresh energy; the middle finger appears to have just moved and hence to have pushed the shroud slightly to one side. Here Holbein has created a completely new and unique narrative image. He has recorded the moment in which the dead Son of God, who had become Man, becomes aware of his divinity and in the next moment will follow his destiny and rise from the dead. The Resurrection is beginning precisely here and now.

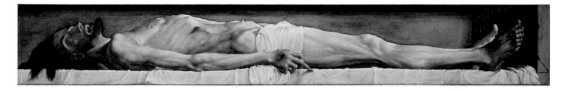

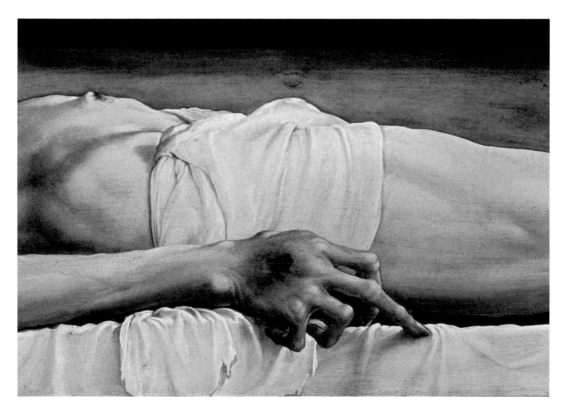

Erasmus of Rotterdam, 1523

Mixed technique on paper, mounted on fir wood
37.1 × 30.8 cm
Kunstmuseum Basel

Hans Holbein's portraits of Erasmus of Rotterdam were extremely important and formative for the artist's international recognition. They acted as door openers for the young Swiss painter. Erasmus in turn used his likenesses more effectively than anyone else in order to keep his friends and (potential) patrons well disposed. He used all mediums, from elaborate paintings to medallions to woodcuts and copperplate engravings and turned to the most highly skilled men in their various fields: Quentin Massys in Antwerp, Albrecht Dürer in Nuremberg as well as Hans Holbein in Basel. He became aware at the latest of Holbein's talent through his *Portrait of Bonifacius Amerbach* (pages 44/5).

Holbein created several portraits of Erasmus; Basilius Amerbach, the son of Bonifacius and later a collector of Holbein's works, was aware of five in Basel alone. The best-known type of Erasmus portrait shows the scholar writing; two such likenesses have survived, painted by Holbein in 1523. On the Basel picture we see the scholar sitting at a desk, concentrating, with a reed pen in his right hand whilst his left hand steadies the paper. He is wearing a lined silk gown and the obligatory beret; the Humanist tended to hypochondria and was known as the "eternally freezing" Erasmus. It looks as if we have just entered the room and could look over his shoulder as he works. The scene looks ordinary enough, but that is by no means the case. This form of scholarly portrait is carefully thought out and is in the tradition of the depictions of the Evangelists and the Fathers of the Church—in other words, anything and everything that was holy and sacred, with Erasmus placing himself in the midst of which in a self-confident manner.

These portraits also served as advertisements for the subject when applying for positions or financial support. Erasmus, however, managed to remain an independent scholar throughout his life, without having to submit to the whims of a king or some other potentate. In this picture he is 'writing' the commentary to St Mark's Gospel, which he dedicated to François I, King of France.

For Holbein, too, portraits were a form of advertisement; the international fame of his work enabled him to present himself in various circles and thus to get a foot in the door of important patrons. Accordingly, Holbein took this version with him to France, where it was to serve him as an entry ticket to the royal court, and the portrait now in the Louvre in Paris, he carried in his luggage for England as Erasmus' gift to Sir Thomas More.

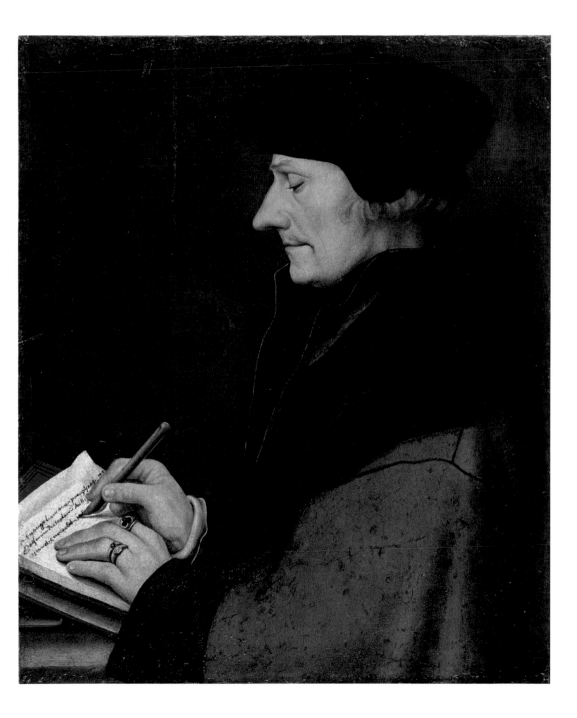

Erasmus of Rotterdam, 1523

Oil on wood
73.6 × 51.4 cm
The National Gallery, London

Holbein's portrait of Erasmus in London is the most prestigious version of the various likenesses as regards both format and finish. Erasmus is sitting in three-quarters profile at a desk wearing his cap and a tabard lined with fine fur. His hands are resting on a book with gold edging, bound in fine leather; on the cover we can read, in Greek, "The Labours of Hercules" and "Erasmi Rotero" (Erasmus of Rotterdam). This by no means implies that here Erasmus has described or commented the twelve labours of Hercules, but rather that the scholar's tasks correspond to those of Hercules in the intellectual sphere. If we remember the relatively slight build of the Humanist and his talent for humour, the comparison of the "two" Hercules could well be intended as a self-ironic comment. William Warham, the Archbishop of Canterbury (pages 68/9), for whom this painting was intended, would presumably have understood the allusion.

Behind Erasmus an ornate column rises upwards, its capital decorated with a siren. A second column can be seen behind it, in the shadows; architecturally speaking, its position is rather strange. A curtain reveals a view of a corbel, on which three books and a glass carafe can be seen. On the propped-up book we can read the date "MDXXIII" (1523); on the edge is a two-line text which can probably be attributed to Erasmus: "I am Johannes Holbein, who will less easily find an imitator than a detractor." Here Erasmus is quoting the gist of a saying by Pliny the Elder, who attributed to Zeuxis, the painter from Antiquity, the comment that it was easier to find fault than to imitate (nature). By comparing Holbein with his fellow colleagues Erasmus is praising the artist, and initially it sounds like honourable praise. By choosing Zeuxis, however, he pours vinegar into the wine, because in the popular comparison with painters of Antiquity it was always Apelles who occupied first place, followed by Parrhasios and Zeuxis. However, since Zeuxis was defeated by the former in a contest, he actually only occupied third place. The sequence was thus the one in which Erasmus classified his contemporaries: Albrecht Dürer was the uncontested new Apelles, Quentin Massys was the Parrhasios and the young Holbein was the Zeuxis. In order to counter this list with a comment of his own, Holbein painted a curtain in a perfectly illusionistic manner, since it was a curtain that played a decisive role in the aforementioned contest between Zeuxis and Parrhasios, and behind it he placed a glass bottle which would have been a credit to any Dutch painter, thereby moving, as it were, into a position ahead of Parrhasios, or rather Massys. This was how a true master narrated hidden messages.

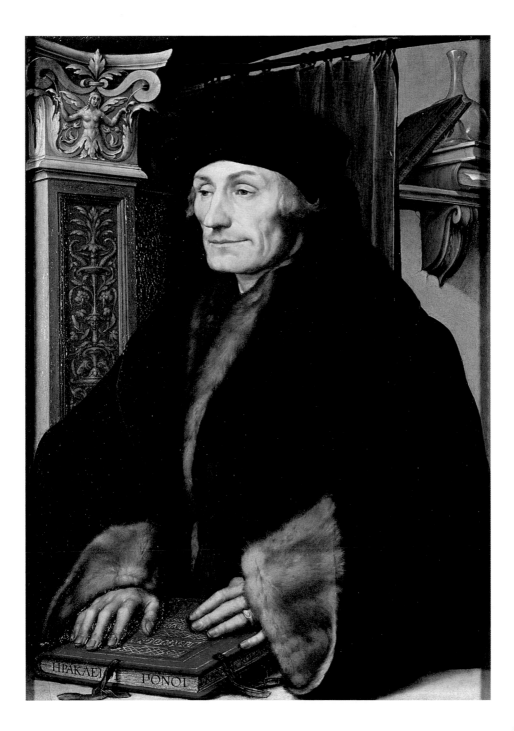

Passion Altarpiece, c. 1524–1526

Oil on lime wood
149.5 × 124 cm
Kunstmuseum Basel

On this panel Hans Holbein follows the conventional narrative of the Passion of Christ with the scene on the Mount of Olives, Christ's Arrest, Christ being Questioned by the High Priest Caiaphas, and the Scourging as well as—in the lower row—the Mocking of Christ, Christ Carrying the Cross, the Crucifixion and finally the Entombment. The eight scenes are painted on four rectangular lime-wood panels which are each divided in the middle by gold ornamentation.

In spite of the traditional structure, which resembles his father's Kaisheim Altar (1502), the execution is new and dramatic in design. Following the Gospel narrative, night scenes or dark interiors predominate; only the Carrying of the Cross takes place during the day. In this scene, however, to herald the Crucifixion, as it were, the dark clouds are gathering; they will become denser to form the night-like darkness mentioned in the Gospels and are also visible in the Entombment. Holbein uses these subtle transitions to link the scenes loosely but logically together: the clouds over the Garden of Gethsemane are continued into the Arrest of Christ, and the people and the torches seem to lead almost without transition from the Arrest to the Questioning by Caiaphas.

Holbein is at great pains to introduce dramatic lighting moods. In this he is notably successful. The tree illuminated by torches frames the Arrest of Jesus most effectively, although he does not always consistently pursue the logic of light and shade. The scene before Caiaphas is illuminated by four torches which cast harsh shadows onto the architecture. However, there must also be another light source outside the picture, resulting in the dramatic shadow on the floor cast by the soldier with the helmet.

It is impressive to see how Holbein succeeds in taming the crowds of people in the four central fields within his composition without making the four outer fields look empty by comparison. Typical of Holbein's work at this time are the elaborate architectural settings, which, as in the case of the scene of the Scourging, can often be traced back to real buildings. Here the reference is the abbey church of Ottmarsheim, not far from Basel.

The *Passion Altarpiece* is documented as having been in the chapel of Basel Town Hall since 1642. It was one of the city's most famous landmarks and as such was highly coveted. Neither copies nor engravings could be made of the work. In 1644, Duke Maximilian I of Bavaria offered 10,000 guilders for a copy. That was a vast sum, when we remember that in 1528 Holbein had sold his house for 300 guilders. The City of Basel declined the offer.

Laïs Corinthiaca, 1526

Mixed technique on lime wood
35.6 × 26.7 cm
Kunstmuseum Basel

When Hans Holbein set off for France in the spring of 1524, most probably with the aim of trying to acquire commissions or even a post at the court of the art-loving King François I, he came into contact with Italian painting from Leonardo da Vinci's circle. We do not know whom he actually met and whether he was able to advance to see the King himself. It is certain, however, that he saw a number of artworks which greatly influenced his work: works by Leonardo, including the *Virgin of the Rocks*, and pictures by the latter's former assistant Andrea Solario, such as his *Salome*. It is not certain whether Holbein painted his *Laïs* in France, nor does it really matter. What is important is that the two ladies, Laïs and Salome, look like sisters.

Holbein's painting tells of the most desirable and expensive hetaera in Greece during the fourth century BC, a highly educated prostitute of Antiquity who is said to have had famous customers as lovers, including the orator Demosthenes, the painters Apelles and Parrhasios, and Diogenes, the philosopher who lived in a barrel (the latter without charge). Holbein painted a kind of beauty typical of the Italian, 'Leonardesque' style. Clad in an elaborate gown, Laïs is sitting behind a balustrade bearing her name, imperiously extending her hand towards the viewer. Pictures of courtesans were also very popular in Italy, with the difference being that in Italy the ladies were usually scantily dressed, for example simply with a sheet. Holbein shunned nudity, although he, too, made use of the sheet. It looks like Laïs is in the process of negotiating and as if she will gather up her sheet, rise to her feet and disappear behind the green curtain unless a few more gold coins are added to the ones already lying on the balustrade. Her gaze appears to be directed not towards a customer, or rather the viewer, but rather towards his purse. The hand is emphasised by a shadow, while the gold coins, like her golden hair accessories and the appliqué ornaments on her gown, glitter thanks to the so-called shell gold or brush gold, by means of which real gold was applied to the picture.

The painting with its enamel-like gloss and the complete invisibility of any brush-strokes is a brilliant showpiece. Unfortunately, we do not know whether Holbein painted it for himself, for a customer or by way of self-promotion, as it were. However, it is evident that he used this type of woman again in the *Solothurn Madonna* (page 17) and also in the *Darmstadt Madonna* (pages 62/3).

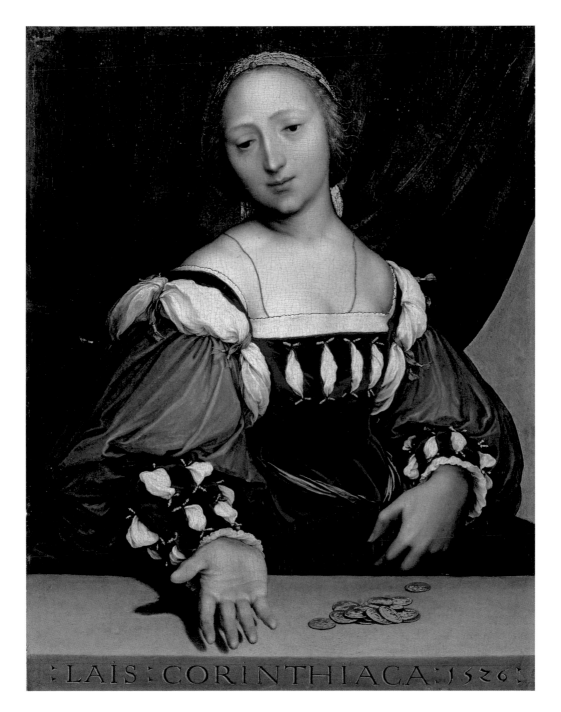

: LAIS : CORINTHIACA : 1526 :

Madonna of the Lord Mayor of Basel, Jakob Meyer zum Hasen, the so-called "Darmstadt Madonna", 1525/6 and 1528

Oil on coniferous wood (?)
146.5 × 102 cm
Johanniterkirche, Schwäbisch Hall, Würth Collection

Hans Holbein received his last major religious commission from Jakob Meyer, who had also given him his first important commission in 1516 with the *Double Portrait of Jakob Meyer zum Hasen and his Wife Dorothea Kannengießer* (pages 40/41). We do not know exactly what the mayor's instructions were, but the work Holbein produced became one of the most important sixteenth-century paintings north of the Alps. The type of the "Virgin of Mercy" was no doubt the basis for the order. And Meyer evidently needed her protection, because in 1521 he had been removed from the office of mayor and arrested briefly following accusations of bribery. Moreover, he remained faithful to his Catholic beliefs in spite of the strong current of Protestantism leading to the iconoclasm of 1529; in this context, the picture of the Madonna was a bold statement. Especially as the Madonna's crown—no doubt on Meyer's instructions—bears a strong resemblance to that of the Holy Roman Empire of the German Nation, thereby corroborating Meyer's critical attitude towards the disengagement of Basel from the imperial federation.

Holbein combines several patterns of image for the Virgin Mary: the Virgin of Mercy, which was popular in the South German region; the Queen of Heaven standing before the Throne; and the Virgin Mary with Jesus and John the Baptist as children. Here he makes use on the one hand of the Italian figurative style which he had encountered in Paris, linking it with the perfectionistic painting and enamel-like surface treatment of the Dutch artists.

The donor is kneeling on the left in front of the Madonna; on the right are his first wife Magdalena Baer, who had died in 1511, his second wife Dorothea and his daughter Anna as a teenager. The identity of the two boys in front of Meyer is less clear. There are many suggestions as to who they might be. It is not unlikely that the elder child is his son, who was born in 1504 and apparently died young (in Meyer's will only Dorothea and Anna are mentioned). The younger child would then be a second son, who had been baptised but had died in infancy as an "innocent child", as the saying was at the time. The reason why these two and the Madonna are shown with idealised features lies in the lack of portrait references and the Italian influence exerted by pictures like Leonardo da Vinci's *Virgin of the Rocks*.

In the light of this interpretation, it seems quite possible that this work was intended as an epitaph for the Meyer family in St Martin's Church in Basel, where the family tomb was located. In this case, the boys would point to the tomb and the hand of the Infant Jesus raised in blessing would be commending the family to the protection of the Madonna.

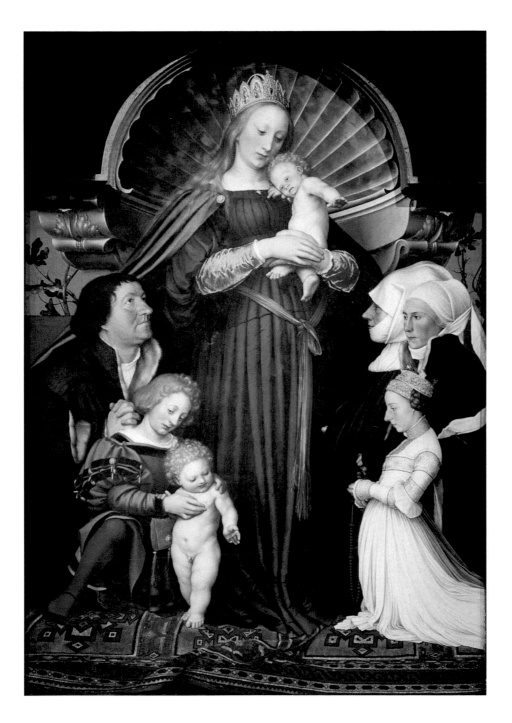

Sir Thomas More, 1527

Oil on oak panel
74.9 × 60.3 cm
The Frick Collection, New York

"Your painter, dearest Erasmus, is a wonderful artist," wrote Sir Thomas More (c. 1477–1535) of the recently arrived Hans Holbein in December 1526. Although the signature indicates that the portrait was not completed until 1527, Holbein had evidently already convinced his host with the preparatory drawings. In this painting of the author of *Utopia*, the young artist created a magnificent work that aroused great enthusiasm not only on the part of More himself, but also from his circle. Thomas More was not just the author of the classic work on political philosophy, which Hans Holbein's elder brother Ambrosius had illustrated as early as 1518 for Johann Froben's edition; he was also an ennobled member of the Privy Council, a Member of Parliament and had been the Speaker of the House of Commons since 1523, as his heavy gold chain indicates only too clearly. The lawyer and politician, who was considered a modest man, was not wearing it in the less official preliminary drawing. Painting More's portrait represented both a challenge and a great opportunity for Holbein, and he successfully used it to good advantage.

Holbein's likeness is psychologically apt and artistically brilliant. As in his *Laïs Corinthiaca* (pages 60/61) he made use of expressive colours and contrasts, which make the painting positively shine, as it were. The red velvet of the sleeves glows as if on fire, in contrast with the purple-black of the gown and the vibrant green of the curtain at the back. No fabric would produce such an effect with normal lighting. Without being distracted by the details, we can recognise every nuance, from the finest quality of the sable of More's tabard to the lines around his eyes and the hints of grey in the stubble on his chin.

Holbein brings the viewer in close contact with More; he occupies almost the entire surface of the picture, thereby increasing his presence. Beyond the powerful harmony of the colours, More's gaze is focused on the distance; it is an expression of total concentration, attention and also determination. If the viewer imagines that he is being looked at, he could get the impression that he has indeed come too close.

In this picture, too, Holbein has included one of his little hints regarding the question of image and likeness. The red cord in the background is hanging strangely without purpose in front of the green curtain, but its dark shadow emphasises the painted three-dimensional image space. Further down it no longer casts a shadow on the wall, so that Holbein reminds us of the two-dimensionality of the picture itself.

Holbein did not disappoint the expectations of Erasmus and More. With this portrait he confirmed his reputation. Thomas More himself, who was Lord Chancellor between 1529 and 1532, was a Catholic and refused to swear an oath confirming the supremacy of the King over the Church. He was arrested and subsequently beheaded on 6 July 1535.

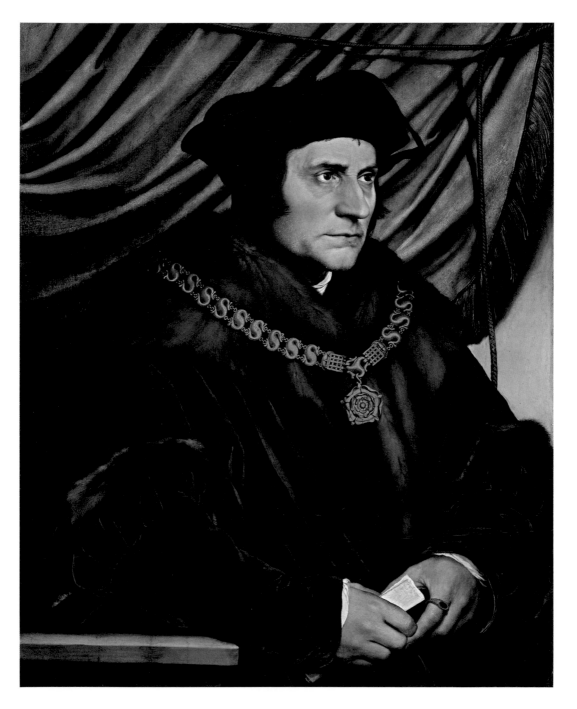

Study for the Family Portrait of Sir Thomas More, 1527

Pen and brush in black over chalk preliminary drawing, laminated with Japan paper
Sheet: 38.9 × 52.4 cm (two pieces jutting out 2 and 4 cm on the right)
Kunstmuseum Basel, Collection of Prints and Drawings

As he wrote in a letter to Erasmus in December 1526, Sir Thomas More wanted to support the young Holbein as far as possible. He did so by commissioning him to paint a portrait of his family. We do not know whether More or Holbein had the idea of this new type of group portrait; it would be interesting to learn the answer, because this is the first picture of its kind north of the Alps. Nor do we know what the occasion was; it may have been to mark the fiftieth birthday of the famous man, for which the family will have come together (from l. to r.): More's eldest daughter Elizabeth, his foster-daughter Margaret, his father Sir John More, his second foster-daughter, who would marry his son John (to More's right) in 1529. They are joined by (from r. to l.) his second wife Alice, in front of whom is her eldest daughter Margaret Roper, her youngest daughter Cecily, and Henry Patenson, the man in the beret, the More family's jester and the only person who is looking directly at the artist—indicating spiritual kinship?

The monumental painting measured 275 by 366 centimetres and no longer exists. It travelled via a circuitous route to what is now the Czech Republic and was destroyed in a fire in Kroměříž Castle in 1752. What remains is an apparently very accurate copy that is almost the same size as the original and was painted at the end of the sixteenth century by Rowland Lockey. And then there is the famous drawing, which Holbein himself created. He prepared the monumental work with portrait drawings, as usual in the size of the final work; seven of these have survived. Holbein most probably also drew a number of variations on the composition. The Basel study will have been a sort of 'approval sheet' for More, on the basis of which alterations would still have been possible. These have been noted and, as we can see from the copy of the painting, were also carried out. Thus, for example, a number of musical instruments were to be included; Alice More was to sit on the right and be shown with a little monkey; and various books were to be shown lying around.

We can assume that a famous man like Sir Thomas More did not simply want a reminder of a family occasion; nor does the overall arrangement really look like a family celebration. Instead, the scene was intended to illustrate More's ideas and principles which he had devised in *Utopia* and at least implemented within his own family: the precedence of the common good, based on the satisfaction of the reasonable individual and founded on freedom of religion, education (especially also for women), tolerance, moderation and diligence.

William Warham, 1527

Oil on wooden panel
82 × 66 cm
Musée du Louvre, Paris

Erasmus von Rotterdam had good reason to be grateful to William Warham (1450–1532). Together with Sir Thomas More, the Archbishop of Canterbury, who had a decisive influence on the fate of England, he was one of his greatest supporters. In 1511, he made Erasmus Rector of Saint Martin's Church in Adlington while he was still teaching in Cambridge. We can see how much the two men meant to each other through the portraits which they exchanged with the help of Hans Holbein. In 1526 the artist brought his portrait of Erasmus to the Archbishop (pages 56/7), and the latter in turn had a magnificent counterpart painted for Erasmus.

Warham was almost 80 years old at the time. He is sitting at a desk in his private chapel with his hands on a brocade cushion. It is the same pose as that adopted by Erasmus in his portrait, but the difference is that Warham does not have a book in front of him. It looks as if the Archbishop is expecting a corresponding work by his friend to be brought to him at any moment. Instead of the column in the picture of Erasmus, here the Archbishop is framed by the insignia of his office. The regalia in all their glory seem unremovably fixed, similar to Warham's unwavering faith, to which he remained true until his—natural—death, in spite of and in opposition to the new order of the Church and state in England. Warham was an important intermediary between Pope Julius II and Henry VIII; the annulment of the marriage between the King and Catherine of Aragon, which he had personally blessed in 1509, must have been difficult for him to accept.

Warham's breviary lies beside him, shown in a fairly steep perspective; on the left next to him is a gleaming gold processional cross that Holbein has painted with shell gold, which he had already used for the gold coins of *Laïs Corinthiaca* (pages 60/61). Behind the Bishop on the right is a mitre richly adorned with pearls and two gilt-edged books lie in front of it. All three have been placed on an item of furniture covered with a Turkish carpet. In the background hangs a heavy damask cloth embroidered in shades of green. Holbein has depicted all these attributes as brilliant still life objects. At the very top edge of the picture he has also included a *trompe-l'oeil* in the form of a so-called *cartellino*, on which the year the work was painted ("MDXXVII") and the age of the subject ("LXX") can be read. If this note had really been fixed to the wall with sealing wax, it would have had to follow the line of the folds in the cloth, which however it does not do. It seems to have been attached directly to the picture. Holbein repeatedly painted artistic details like this into his pictures, posing the question of reality and fiction.

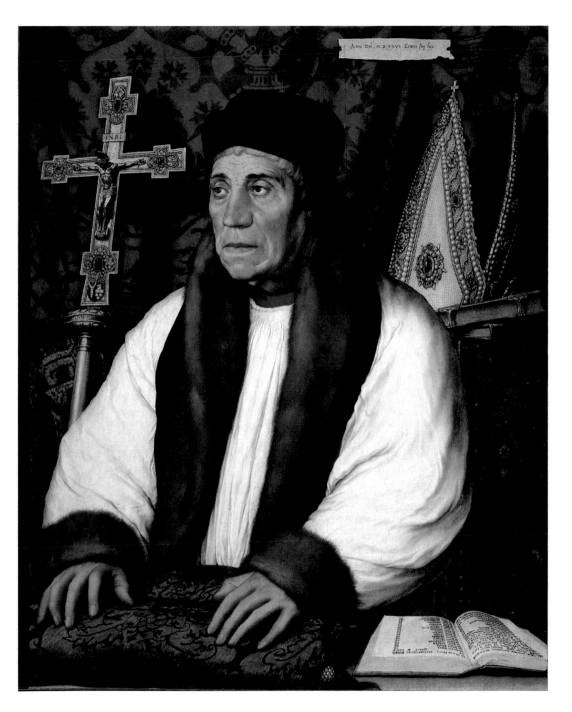

69

Sir Henry Guildford, 1527

Oil on oak panel
82.7 × 66.4 cm
Royal Collection Trust, Hampton Court Palace

Sir Henry Guildford (1489–1532) belonged to the London circle of the Humanists surrounding Sir Thomas More and William Warham; he was also one of Henry VIII's closest confidants and a personal friend. Guildford is sure to have seen Holbein's portrait of his friend More (pages 64/5), and immediately commissioned portraits of himself and his wife, Lady Mary. In these likenesses, too, Holbein demonstrated all his skill and ability. Unlike More, modesty does not seem to have been one of Guildford's more obvious characteristics, and so Holbein shows the Comptroller of the King's Household with the white staff of office signifying his position. He is wearing a tunic of gleaming gold brocade, which the artist has once again depicted with copious amounts of shell gold. Around his shoulders, which appear broad because of the jacket lined with fine fur, hangs the chain of the Order of the Garter, the highest honour which the English monarch can bestow. On each of the medallions is the motto "Hony soyt qui mal y pense" ("Shame on anyone who thinks evil of it"), together with the pendant of St George, the patron saint of England. On Guildford's beret we can see an emblem with a clock and geometrical instruments reminiscent of Albrecht Dürer's masterly engraving *Melencolia I* from 1514. Even the background of the painting is opulent, with royal blue, vines and a rich green curtain suspended from a rod which continues into the companion picture of his wife (page 25) and so links the two together.
Guildford himself is standing in an awe-inspiring pose and seems to step beyond the boundaries of the picture, a device Holbein frequently used in his portraits of important personalities. The complete portrait, together with that of Guildford's second wife Mary, is a demonstration of wealth and power, which the determined-looking friend of the King self-assuredly made use of. On the *cartellino* at top left, which was painted at a later date and not by Holbein, the date (1527) and the age of the subject (49) can be read, although Guildford was only 38 at the time. The age will have been less important in Hans Holbein's eyes than Guildford's function as Master of Ceremonies and organiser of the celebrations to mark the peace treaty between England and France in 1527, which were held in Greenwich and for which Holbein designed a large part of the festive decorations.

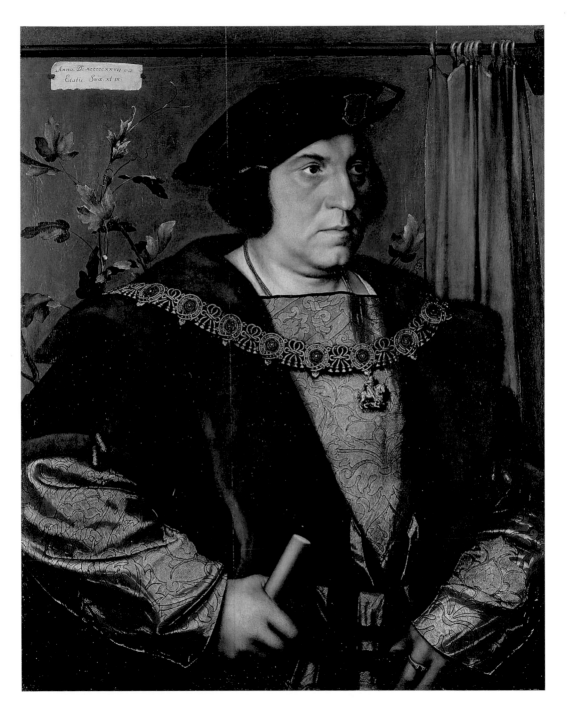

Lady Mary Guildford, 1527

Black and coloured chalk, mounted
52.2 × 38.5 cm (image)
Kunstmuseum Basel, Kupferstichkabinett

Sir Henry Guildford's second wife Mary Wotton (1499–1558) looks extremely earnest on her oil portrait (page 25). Not only earnest, but also somewhat restricted and stiff as a result of the ostentatious display of her sumptuous clothes and elaborate jewellery. We should remember that the lady was only 27 years of age when the portrait was painted.

How different, by contrast, is the preparatory drawing that Holbein made of her. It is probably the most charming portrait that Holbein ever created. We see a somewhat plumper Lady Mary gazing with a restrained but mischievous smile in the direction of her husband, who is portrayed on the companion picture (pages 70/71). Here, too, she is wearing an evidently richly-decorated gown and the angular bonnet that was so fashionable at the time, but she looks far more frank and relaxed, almost merry, compared with the panel painted in oil.

As so often, the faces Holbein drew are more informal and the personalities appear to be more 'recognisable' than in the corresponding paintings. Holbein could evidently work more freely on paper—also from a purely technical point of view, although he used the drawings, including this one, as a direct template with only minor changes. By now Holbein had perfected the art of drawing with black and a handful of coloured chalks. The face with the finely blurred shading is very precise, while on the other hand the clothing and the figure as a whole are sketched out with relaxed, energetic lines.

The fact that in the corresponding painting Lady Mary had to look in a different direction and abandon her charming smile so that her face seems almost to have been 'turned to stone' is probably due to the lofty position of her husband. It corresponded with the wishes of the top-ranking members of society for a distinguished appearance. An ennobling pillar has been placed beside her on the painting; the capital is adorned with a Medusa-like woman's head. This seems to be an artistic comment by Holbein on the fact that he was required to show Lady Mary Guildford as if she has been petrified by Medusa's gaze, as it were, and not portray her with the likeable smile of the drawing—albeit at the risk of Lady Mary's gaze in turn leading to the petrification of the viewer too.

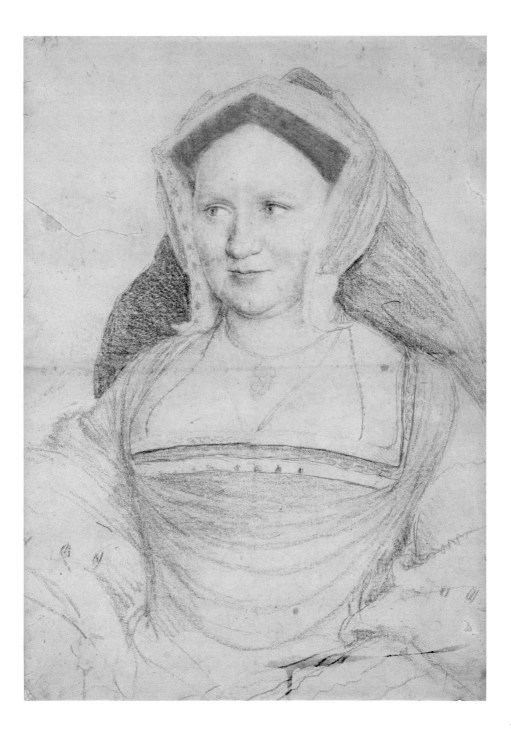

A Lady with a Squirrel and a Starling (Anne Lovell?), c. 1526–28

Oil on oak panel
56 × 38.8 cm
The National Gallery, London

Hans Holbein's painting of a lady holding a squirrel and with a starling sitting behind her is one of the artist's most unusual paintings. Holbein only painted one other portrait in which an animal is to be seen (pages 94/5), and in his other works they are also seldom represented. But this is a remarkable picture not only because of the animals. Here Holbein uses just a few colours to arrive at an elegant composition, which literally challenges the viewer's sense of touch through the masterful description of the materials. We marvel in particular at the harmony of the whites, from the fluffy ermine cap to the multi-layered, rather stiff-looking shawl and the virtually transparent fabric of the bodice, through which we can see the skin shimmering. And then there is the almost sensuous moment when the bushy tip of the squirrel's tail gently brushes across the delicate skin of the lady's décolleté. Perhaps that is why she appears to be blushing slightly. All this takes place in front of an intensely blue background which practically seems to be moving a little through the green tendrils.

Holbein neither signed the picture, nor did he note anywhere the name of the subject of the portrait. In all probability the lady is Anne Lovell, née Ashby, whom Sir Francis Lovell married in 1515. Lovell, in turn, was a loyal personal servant of the King and served as sheriff in Norfolk for twenty years from 1526/7. For a long time, the identification of the lady was uncertain, but was eventually made possible because of the two animals. The starling points towards the ancestral home of the Lovell family, which was situated in East Harling in Norfolk. The village name was written as "Estharlying" at the time and was pronounced in similar fashion to "a starling". The squirrel can be found repeated six times in the coat of arms of the Lovell family. So if the wife of Francis Lovell is seen with the heraldic animal on her lap, it could be a fairly direct reference to the birth of an heir and hence the continuity of the family. It is interesting to note that X-rays have demonstrated that at least the squirrel was not part of the original composition, but was inserted later, together with a change in the position of the hands. Perhaps the good news lay between the awarding of the commission and the final completion of the portrait. However it came about, with this painting Holbein created not only one of his most unusual but also one of his most associative portraits – and above all his most poetic work.

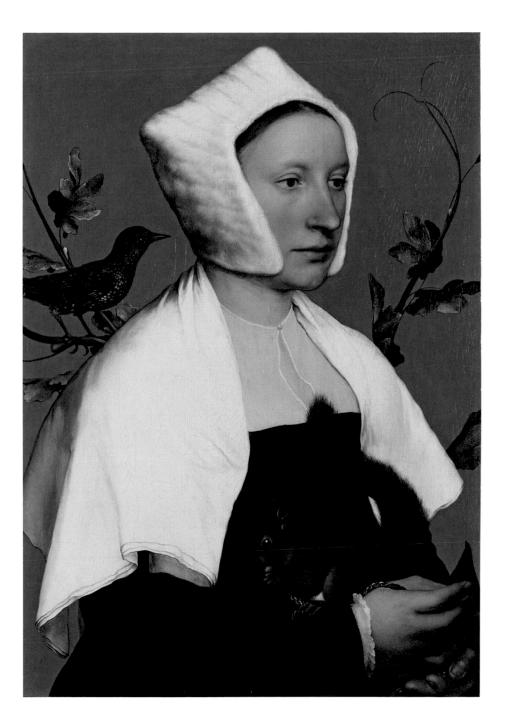

Nikolaus Kratzer, 1528

Tempera on wood
83 × 67 cm
Paris, Musée du Louvre

We do not know how fluent Hans Holbein's English was when he arrived in England for the first time in 1526. However, it was evidently soon sufficiently good for him to be able to make a significant contribution to the decorations for the festivities at the royal court in Greenwich celebrating the peace treaty between France and England. Not unimportant in this respect will have been his successful portrait of Sir Henry Guildford (pages 70/71), who organised the spectacle. When carrying out the project, which also included a ceiling painting with a cosmological representation of the world, Holbein had the support of the court astronomer Nikolaus Kratzer (1487–1550). He was able to discuss matters in detail with him because Kratzer came from Munich, not far from Holbein's birthplace, Augsburg. Kratzer studied Mathematics and Euclidean Geometry in Cologne and Wittenberg and moved to England in 1517, where he was appointed Professor in Oxford and entered the King's service in 1519 as Court Astronomer and instrument-maker.

Kratzer is sitting at his desk in an austerely furnished room, surrounded by instruments and tools. In his hand he is holding a ten-sided sundial and appears to be pausing to think about its construction. Holbein shows him in the three-quarters profile view which he frequently selects for portraits. On the wall hang a ruler, a large pair of compasses and a caliper gauge, and on the shelf behind Kratzer's right shoulder stand a semicircular scale with a swivel arm and a cylindrical sundial, on which we can read the abbreviations "MA", "APR" and "M", which may refer to the months March, April and May, during which Holbein most probably created the painting.

On the table lie various parts of instruments and tools, as well as a note, on which is written in Latin: "A likeness of Nikolaus Kratzer from Munich, painted from life. He was a Bavarian and was 42 years old in 1528." The paper is relatively prominent and, like the awl, juts out over the edge of the table and hence out of the true picture space in classic *trompe-l'oeil* manner. Yet another little artistic hint on the subject of illusion and reality.

The entire portrait radiates a mood of cool precision, which is not so much a description of the subject's personality as a documentation and illustration of the court astronomer through the precision of his instruments and the objectivity of his position and significance for posterity.

Double Portrait of Thomas Godsalve and his Son John, 1528

Oil on oak panel
35 × 36 cm
Gemäldegalerie Alte Meister, Dresden

One of the last commissions which Hans Holbein completed in England was the double portrait of Thomas Godsalve (1481–1545) and his son John (c. 1510–1556). It is not only the smallest of the portraits produced in England, but also by far the least ornamental. The subjects are shown against a plain turquoise-green background without any form of drapery, distinctive architecture or other accessories such as plants or tools. Perhaps this was due to the bourgeois modesty of the notary from Norwich, who was not a member of courtly society. Or perhaps the client did not want to be faced with excessive costs, although he was not short of money—in fact, he was the richest man in his home town. He possibly lived according to the motto that wealth is best acquired not only through a high income but also and above all through low expenses. Nonetheless, he still wanted to have his portrait painted by Holbein, for the artist was certainly popular, bearing in mind who his other clients were.

Holbein has devised a relatively simple composition, adopting the three-quarters profile view which he frequently selected. He had already used it in portraits such as those of Sir Thomas More and Nikolaus Kratzer (pages 64/5 and 76/7), and here he not only repeats it, but actually doubles it, so to speak. And thus, by all means also symbolically, the father Thomas sits to the right in front of his son John, who adopts the same position behind him and thus follows him, not only in the picture but also in life. Both men are looking to the right beyond the picture; however, we are not under the impression that either of them is pondering about something as Kratzer or More evidently are—they are simply looking. Admittedly, the father is holding a pen and paper, but it does not seem as if he has just looked up from his writing, because the written text is complete as it stands and states: "Thomas Godsalve de Norwico Etatis sue Anno / quadragesimo septo" ("Thomas Godsalve from Norwich at the age of 47 years"), as if it were a notarial certification that he is examining. His son John, who is also holding a sheet of paper, is not mentioned. This does not imply anything negative regarding the relationship between father and son: through his contacts, including those to Thomas Cromwell (pages 86/7), the father initiated everything in order to ensure his son's entry into courtly circles. John Godsalve became a Member of Parliament, was knighted in 1547 and also became Comptroller of the Royal Mint. His career was thus equally successful, a fact which he also wanted to document with a further portrait by Hans Holbein. Although only a preliminary drawing exists, it is one of the most impressive works produced by the artist.

The Artist's Family, c. 1528/9

Mixed technique on paper, with the outline of the figures cut out and mounted on lime wood
79.4 × 64.7 cm
Kunstmuseum Basel

In the case of some subjects we may assume that they must have been natural choices for artists. This is apparently not the case, however. Just as Holbein created something new with his portrait of the family of Sir Thomas More (pages 66/7), for artists the depiction of their own family—with few exceptions—seems not to have been an issue. Holbein is one of the first who casts a look—and apparently a very intimate one at that—at his wife and children. The picture was produced in 1528 or 1529, after Holbein's first long sojourn in England. It shows his wife, Elsbeth Binzenstock, who at this stage was about 34 years old, together with their son Philipp (aged about 6) and their daughter Katharina at the age of about 2.

None of the three looks particularly happy or even cheerful. Philipp is looking up with an air of concern, Katharina appears to want to head off somewhere else and Elsbeth looks tired and resigned. Holbein does not show an idealised picture of a mother reminiscent of the Virgin Mary, but rather a woman who seems to have aged prematurely and who is gazing exhaustedly in front of her. In general, the trio seems to have been placed rather strangely in the picture. If we look more carefully, it becomes clear that the picture has been cut out around the figures and probably also at the bottom. At the lower right-hand edge of the picture we can see part of a date: "152". Then the figures were glued to a black background. The picture was probably part of a sort of family portrait showing the artist and his family, designed in such a way that Holbein had positioned himself on the right-hand side of the panel, and was shown painting his family. This recalls Saint Luke the Evangelist, who painted the Virgin Mary and thus became the patron saint of artists, an image that some painters made use of in their self-portraits.

What was the purpose of the picture? Did Holbein want to commemorate his family or was it a demonstration of a new pictorial idea and hence a new business model? Holbein had returned to a city in which there were very few worthwhile commissions for artists, especially those of his calibre, as a result of the Protestant hostility to icons. The pyramidal composition of the painting recalls Leonardo da Vinci's s *The Virgin and Child with Saint Anne* or the *Virgin of the Rocks*, which Holbein had probably seen in Paris. Perhaps he saw it as a possibility to create and aim to sell a religious motif, the Holy Family, secularised, so to speak, for a bourgeois audience which was denied religious pictures. The free art market which developed from the Calvinist hostility to icons in the Netherlands during the seventeenth century did not yet exist.

We do not know why Elsbeth sold the picture in 1542, while her husband was still alive. Perhaps she needed the money, or perhaps she had already realised that her marriage was long since over, because although the couple had two further children, Holbein remained in England, where he probably had a second wife, because he also had two children there.

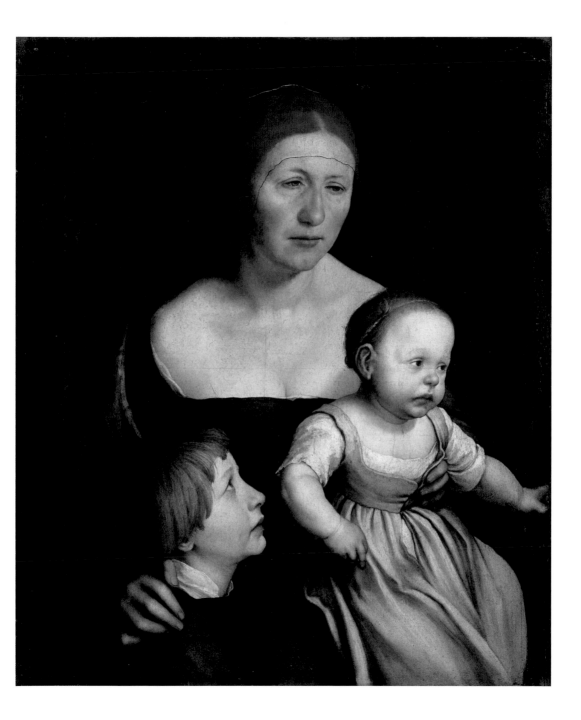

Pictures for the Wings of the Organ in the Basel Minster, c. 1525/6 or 1528

Distemper on canvas
282.5 × 455 cm
Kunstmuseum Basel

In their original location in the Basel Minster, the two great wings covered the organ as required until 1786. On the left we see Saint Kunigunde with her husband Emperor Heinrich II (c. 973–1024), and on the right, the Virgin Mary with the Infant Jesus, eight angel musicians and Saint Pantalus (fourth to fifth century), the legendary first Bishop of Basel. The panels are painted on canvas, and the shades of brown used by Holbein imitate those of unpainted wooden figures. The artist, who perhaps also created the designs for the organ housing that was actually carved, thus embarks here on the classical *paragone*, the contest between painting and sculpture. He masterfully decides in favour of painting because he not only succeeds in imitating, but he also creates spaces where there are none. Thus, the image of the Minster and the angelic musicians extend pictorially into a spatial depth which is illusionary.

Saint Kunigunde is carrying a cross which refers to the relic of the Cross which she donated to the Minster; seen from the south-east, the Minster is itself a reference to its foundation by the imperial couple, who were deeply venerated in Basel. As previously in the case of the *Passion Altarpiece* (pages 58/9), Holbein subtly links together the separate panels, in this case through the cross, the foot of which rises up above the roof of the Minster, and on the other side with the right hand of the bishop, which is pointing towards the angels. Only the Emperor's gaze connects Heinrich II and the Virgin Mary, because originally the organ lay between them. Holbein uses *trompe-l'oeil* effects in order to pose the question of reality and illusion. Here he uses the Emperor's right foot, which appears to jut out over the balustrade, and his cloak, which disappears behind the frame, while his bent arm seems to protrude well beyond the picture plane.

The panels are painted with a pronounced low-angle view, because, after all, they were located at a height of eleven metres. This would also explain the Virgin Mary's apparently anxious gaze—and would perhaps also have been what saved the works from the destructive fury of the iconoclasts in the years 1528/9. We might even interpret the Virgin Mary's frightened look as apprehension about the destructive havoc during the iconoclasm taking place at her feet, which Holbein may have seen coming. It is not certain when Holbein created the panels, but it was not least because of the Protestant hostility towards icons that this remained his last great work commissioned by the Church.

Georg Gisze, 1532

Oil on oak panel
97.5 × 86.2 cm
Gemäldegalerie, Berlin

For this painting two individuals came together who seem to have had the same intentions: the first was Georg Gisze (1497–1562), the merchant from Danzig, and the other was Hans Holbein the artist from Basel, who was the same age as his client. Both wanted to convince the viewer of their abilities and/or their success, and both pursued their activities far from home, in London. The citizen of Danzig shows his offices, adorned with numerous prestigious objects; the Basel artist demonstrates the entire spectrum of his art.

Gisze seems to set great store by presenting himself as an internationally successful merchant. It was intended that the numerous accessories—the gold scales, the money box, the clock watch, books, seal, quills and the valuable carpet should demonstrate this. He also evidently set equally great store by the mention of his name, which can be read in various places throughout the office: on the letters, on the seals, on the cartellino and again, written as if with chalk, on the wall below his motto "Nulla sine merore voluptas" ("No pain, no gain"). Despite all the letters and implements, what is not evident, however, is what the merchant Georg Gisze actually traded in. Perhaps it was not relevant for this picture, because it could have been a gift to his bride in Danzig, indicated by the flowers in the brilliantly painted vase (carnations for betrothal, rosemary for faithfulness and hyssop for health). Gisze did actually marry in Danzig three years later.

Hans Holbein uses his illusionist skills to show the entire magnificence of the merchant's success. Despite the pomp, however, what seems a little odd is the confined space afforded by the office. That is due to the original concept for the picture, which was different, and in which the wall on the right was not planned. Gisze evidently considered it necessary, however, because how could one otherwise have shown the countless letters and seals in an elegant manner? It also looks as if the right sleeve may have had to sacrifice a little of its volume. There is another reference to the merchant above his head. There it states that the picture shows him at the age of 34 years; but this label belongs in the world of the viewer, as it were, because it seems to have been stuck onto the surface of the picture; otherwise, we cannot explain how it could cover the book that is lying in front of it on the left.

This painting was also an advertisement for Holbein. It showed his supreme ability in portraying a successful merchant. That was important, given that, for the time being, any commissions from courtly circles were failing to materialise because of the changed political circumstances.

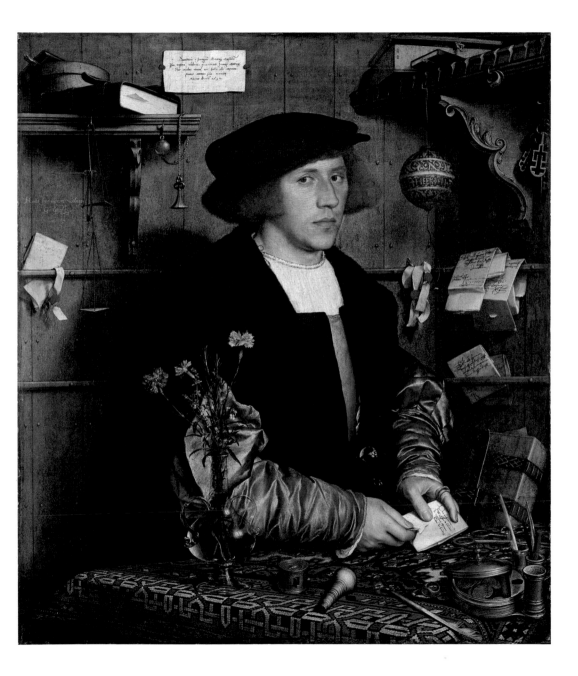

Thomas Cromwell, 1532/3

Oil on oak panel
78.1 × 64.1 cm
The Frick Collection, New York

During his second sojourn in England, Holbein evidently quickly established contacts to highly influential people, as he had during his first visit. Apart from the King, Thomas Cromwell (c. 1485–1540) was the most influential of all. He came from a humble background but had skilfully worked his way up to the highest positions within the state, and had gained the trust of Henry VIII. He was ultimately the architect of the Act of Supremacy, which made the King the Head of the Anglican Church in 1534.

Holbein positions the power-conscious politician in a rigorous composition determined by vertical and horizontal lines. Everything seems to be orderly and to have its place, even though Cromwell looks a little cramped between the table and the wall. Perhaps that is symbolic of the constraints with which he had to cope during his career. And the wallpaper that is coming away from the wall on the left, and which he has evidently not noticed, might possibly not bode well (yet another of Holbein's painterly comments?). At the time when Holbein created this portrait, Cromwell was the Master of the Jewel Office, as the note on the table confirms. His career, however, would take him even further still: in 1534 he became the King's Secretary and Master of the Rolls, in other words the second most important judge in the country. The office of Lord Privy Seal followed in 1536, as well as membership of the Order of the Garter; as vicar general Cromwell became the King's vice-regent. He rigorously pursued the dissolution of the monasteries. This brought him unflattering nicknames like "Hammer of the Monks" and "The Devil's Emissary". In the prize-winning trilogy on the subject of Thomas Cromwell by the British writer Hilary Mantel, Cromwell and his son Gregory study Holbein's portrait and he speaks of an acquaintance: "I heard him say that I look like a murderer." Whereupon his son replies: "Didn't you know that?"

Towards the end of the decade Cromwell, in search of a new wife for Henry VIII, decides in favour of Anne of Cleves (pages 102/3), in order to establish connections to influential German Protestants. As we know, this project failed and shortly after the marriage, Cromwell lost not only all his offices, but also on 28 July 1540, his head.

Today his portrait hangs in the Frick Collection in New York, opposite that of Sir Thomas More (pages 64/5), for whose execution in 1535 Cromwell himself had been largely responsible. The two portraits, painted within the space of five years, look full of tension when seen together, as if Hans Holbein had predicted and intended this confrontation.

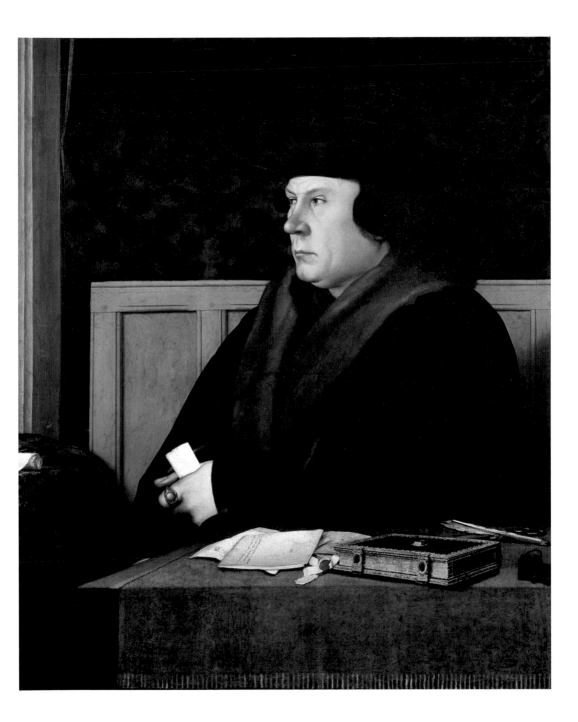

Derich Born, 1533

Oil on oak panel
60.3 × 44.9 cm
Royal Collection Trust, Windsor Castle

"If we were to add the voice, then we would see Derich in the flesh, in such a manner that we might ask ourselves whether the artist or the Creator had made him. Derich Born, 23 years of age, in the year 1533." That is what is 'carved in stone' on the balustrade against which the aforementioned Derich Born (1510?-1549) is leaning. At the age of 23 he was the youngest member of the German merchants in the "Steelyard" in London (page 31). Unlike Georg Gisze (pages 84/5), he did not want any accessories in the picture which might have described him or his position. He was evidently self-confident enough without them. As the inscription states, the only thing missing for him to be actually present is his voice. Holbein refers here to the classic comparison of contemporary painters with Apelles and hence to Erasmus of Rotterdam, who saw Holbein in his portrait as Zeuxis and not as the new Apelles (pages 56/7).Apelles, for him, was Albrecht Dürer. So with this signature, Holbein positions himself in the place of Apelles and thus at the same time in that of Dürer, thereby sending an artistic response to his former patron Erasmus of Rotterdam. Apart from that, the picture is an understatement in itself, because if we study just the clothes of the young man, it becomes clear how expensive they are, and Born is well aware that the relevant viewers will see how successful he—or his family— already are. Above all, however, it is his pose and his gaze that Holbein captures with such skill. They radiate not only his pride but in this case also the entire arrogance of youth.

Derich Born was what we should nowadays call an arms dealer. He sold military equipment to the Royal Armourer, Erasmus Kyrkener. In 1541, he and his brother Johannes were involved in a dispute with the powerful Duke of Suffolk regarding the payment for a consignment of lead. As a result of this dispute he was excluded from the remunerative membership of the German trading association in London, because he would otherwise have jeopardised the privileges of all the other merchants.

In this picture, Holbein has succeeded in masterly fashion in portraying Born's personality. His head confronts the viewer from the middle of the picture and is supported within the composition by the elbow positioned exactly in the middle. As the other "Steelyard" portraits—of which there are seven in all—demonstrate, the reserved and modest representation of success and wealth were more in line with the style which appealed to the Hanseatic merchants rather than the ostentatious magnificence of Georg Gisze.

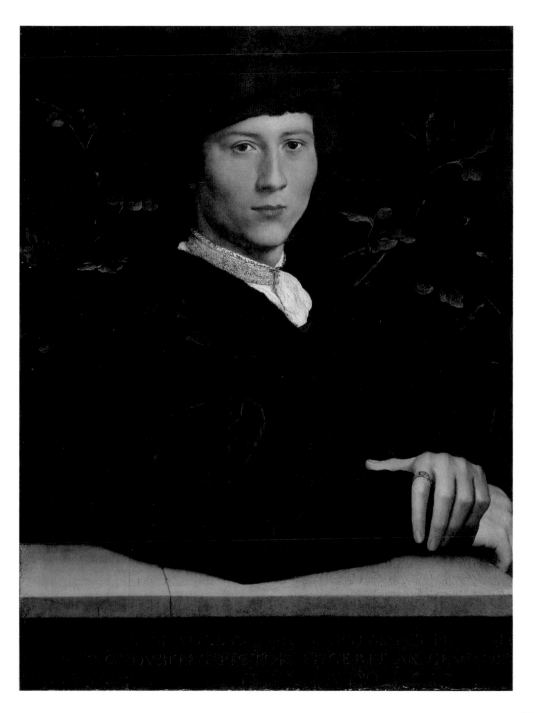

The Ambassadors, 1533

Oil on wood
207 × 209.5 cm
The National Gallery, London

When considering the fame of Hans Holbein's paintings, this picture of the two
French officials at the English court must be among the most famous of all. It is
probably the painting with the most allusions, hints and riddles, openly concealed
in the equipment, globes and books which Holbein has painted in meticulous
detail and on which we can read every letter. Most of them have been placed in the
somewhat crudely carpentered shelf. But also the floor, the background and the
anamorphosis hovering in the sphere in between, contribute to the enigma. What
is less interesting—at least from a present-day point of view—are the two men, for
whose benefit the entire effort has been made. They seem almost to founder in their
gowns amidst this mass of information. They should be introduced nonetheless: on
the left stands Jean de Dinteville, the ambassador of the King of France, François I,
who is to report to the latter on Henry VIII's divorce from Catherine of Aragon and
subsequent developments. At the time this portrait was painted he was 29 years of
age, as we can read on the hilt of his dagger. The gentleman on the right is Bishop
Georges de Selve, whose age on the book under his arm is given as 25 years. He is
on a secret mission to England. He arrived in London in May 1533 and left again on
4 June. Holbein must at least have developed the concept and the young bishop's
portrait drawing within this short space of time. At first sight the composition does
not look particularly complex: two friends are standing, leaning on a shelf filled with
equipment from art and science, whereby some items were evidently borrowed
from *Nikolaus Kratzer* (pages 76/7). They reflect the men's interests and symbolise
their status.

The distorted skull in the foreground, painted as an anamorphosis, opens up the
possibility of interpreting the entire picture as a vanitas representation: death is
omnipresent, even if it cannot always be immediately recognised as such. The skull
divides the picture into two systems, Life and Death: it can only be viewed from a
normal perspective as such from a point on the extreme left. Just when we succeed
in identifying Death, however, we can no longer identify with the picture, in other
words, with life itself, properly. Only one dimension can ever endure and so, even
if Life and Death are united in this picture, they exclude each other mutually and
cannot co-exist for the viewer, that is, for man. The only salvation appears at top
left in the form of a crucifix. What lies behind the curtain which almost completely
covers the crucifix, is perhaps only perceivable in death.

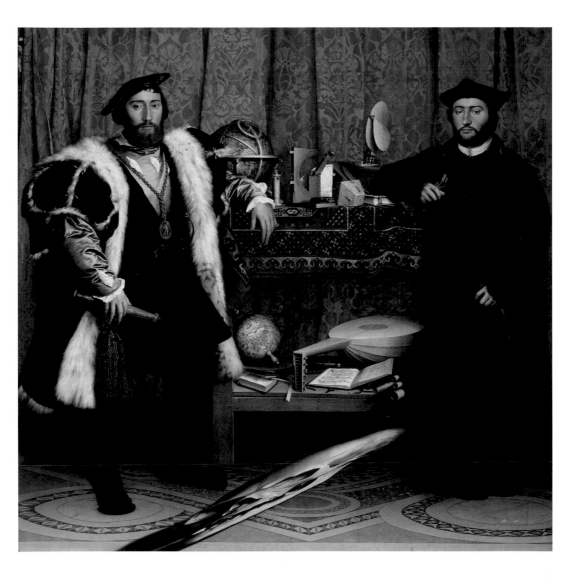

Charles de Solier, Sieur de Morette, 1534/5

Oil on oak panel
92.5 × 75.5 cm
Gemäldegalerie Alte Meister, Dresden

Charles de Solier, Sieur de Morette (1480–1552) was a soldier, commander and chamberlain of the French King François I, and he succeeded Jean de Dinteville (pages 90/91) as his ambassador at the English court. He was quite obviously a completely different personality. Unlike his predecessor he is a clearly discernable person, although he remains inscrutable. He gazes directly at the viewer and we believe that in this directness we can detect a strong will and extensive experience of life, gained from both victories and defeats. He needs no elaborate accessories and seems to be facing the portraitist attentively, but with a degree of scepticism. Here Holbein has created one of his most impressive likenesses, in which he is concentrating entirely on the person and his character on the one hand, and demonstrating a rare brilliance in his painting technique on the other. A harmonious blend of dark shades of black, green and brown orchestrate the subject's concentrated presence, leavened only by the white of the sleeves and the gold of the items of jewellery. All the surfaces, from the fabrics and the precious metal to the hair and the skin on de Solier's right hand, are recorded on the panel with a rarely encountered realism. The dagger and its sheath look as if they have been chiselled rather than painted.

Holbein may have taken Jean Clouet's *Portrait of François I*, that he must have seen in Paris, as a reference or inspiration for this type of portrait. But unlike the French painting, Holbein has dispensed with Clouet's good-natured flattery and softness. Compared with the works of his French or Italian colleagues, Holbein's likenesses are usually more direct and merciless, which in this case may well have also been due to the subject. In spite of his obsession to detail, Holbein succeeds in imbuing de Solier with an inner greatness which derives from the actual simplicity of the composition.

As in the case of *The Ambassadors* (pages 90/91), Holbein may perhaps have hoped that this portrait, which is outstanding even within his oeuvre, would be seen at the French court and might thus have opened up an opportunity for him to offer his services to François I, who was a greater patron of the arts than Henry VIII—but in vain. The painting also had a remarkable provenance history: in 1746, Augustus III of Saxony acquired the picture in Modena believing it to be the portrait of Ludovico Sforza, painted by no less than Leonardo da Vinci. It had arrived there, unsigned and without a name, via the convoluted paths of the art trade. In this case, it would have been Leonardo who would have felt flattered by the mistake.

Robert Cheseman, 1533

Oil on wood
58.8 × 62.8 cm
Mauritshuis, Den Haag

This portrait is unusual in Holbein's oeuvre for several reasons. Firstly, it shows an animal in a prominent position, which hitherto has only occurred in the portrait of Anne Lovell (pages 74/5). Moreover, the subject was neither a courtier, nor a representative of the Church, nor a German merchant. It is also the only solo portrait in landscape format. Hans Holbein evidently required this layout in order to ensure that the falcon and the falconer did not look too cramped. The broad format lends the picture a degree of serenity, which is emphasised in particular by the tension between Cheseman's concentrated gaze towards the left as well as his calming hand movement towards the falcon. The breadth of the composition is heightened by the writing, which tells us the name and age (48 years) of the subject and supplies the date as 1533.

It has often been maintained that Robert Cheseman was the King's Falconer. This, however, seems highly unlikely, since Holbein, with a few exceptions amongst his miniature portraits, never portrayed servants; moreover, the man's clothing is far too expensive. In fact, Cheseman was a wealthy country aristocrat whose father Edward had served Henry VII as chamberlain and confidant. He left his son Robert considerable property in Kent and Middlesex, which also enabled him to purchase a house in London in the same neighbourhood as Holbein. There are no documents that would confirm that Cheseman had a function or position at court, let alone that he was the Royal Falconer. His career included becoming a Justice of the Peace in Middlesex in 1528 and he was responsible for various commissions, among them tax collection. As part of his estate he founded a poorhouse for twelve needy women, for which a memorial in his honour in the chapel at Norwood was erected after his death in 1547. So falconry was evidently simply an important pastime for him, as it was for many noblemen, including Sir Ralph Sadler, whom Holbein also immortalised in a miniature portrait.

It seems as if Cheseman has adopted the penetrating gaze of his falcon, which the bird is denied at this moment because of the calming leather hood. The picture captivates the viewer with its unusual colour combination of blue and dark grey, which is heightened by the red silk sleeves and the brass bell.

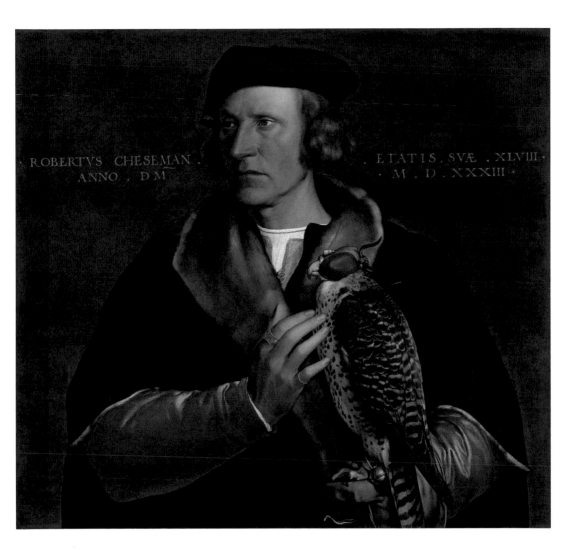

Solomon and the Queen of Sheba, c. 1534

Mixed technique on parchment
22.9 × 18.3 cm (sheet)
Royal Collection Trust

This exquisite little drawing was a New Year's gift to Henry VIII from Hans Holbein, who was presumably already the King's Painter at the time. It shows the visit of the Queen of Sheba (who evidently did not have a proper name?) to the wise King Solomon, as described in the First Book of Kings. The Queen had heard of Solomon's legendary reputation and wanted to establish whether it was true. When she decided that it had been confirmed she praised him: "Thy wisdom and prosperity exceedeth the fame which I heard. Happy are thy men, happy are these thy servants [...]. Blessed be the Lord thy God which delighted in thee, to set thee on the throne of Israel [...]. Therefore he made thee king." The text is written on the background of the picture, on the wall and the fabric.

The Queen of Sheba is traditionally interpreted as embodying the Church, and Solomon is typologically understood to represent Jesus, who is responsible only to God himself. In 1534 Henry VIII had proclaimed himself the head of his own Anglican Church through the Act of Supremacy, therefore becoming answerable only to God. The separation from the Roman Catholic Church and the Pope was thus finally complete. Holbein's little masterpiece was, therefore, a most suitable gift; the subject and the time could not have been more appropriately chosen.

Holbein has arranged the thirty-four figures into various groups with supreme skill: at front left are the Queen's ladies-in-waiting, and her servants are on the right, offering gifts; near Solomon's throne are "men" and "servants" and the Queen is standing in the middle on the steps to deliver her eulogy of the King on the throne. He is somewhat confounding with his rather rough-and-ready pose, having placed his hands on his hips. This makes it clear, however, that the King symbolises Henry VIII. Holbein, of course, has built in a small sly comment, a minor detail which we only notice if we look very closely indeed: The King has splayed the little finger of his left hand. This gesture derives from the wall painting *The Arrogance of Rehaboam* (page 29) in Basel, where it stands for a warning sign of a bad ruler. But who, at the English court, knew the Council Chamber in Basel...?

The work on parchment has been executed in perfect *grisaille* technique using precious silverpoint, ultramarine and gold. It looks as if Henry is wearing the same ruby-studded garment as in the portrait in Madrid (pages 98/9). Incidentally, this is the only portrait-like drawing by Holbein that exists in the Royal Collection of the King of England who founded the Anglican Church.

SIT DOMINVS DEVS TVVS BENEDICTVS
CVI COMPLACIT IN TE VT PONERET E
SVPER THRONVM SVVM VT ESSES REX
CONSTITVTVS DOMINO DEO TVO

ET BEATI SERVI HI TV
OMNITAE ET AVDIVNT
TV

VICISTI FAMAM
VIRTVTIBVS TVIS

REGINA SABA

Portrait of Henry VIII of England, c. 1537

Oil on wood
28 × 20 cm
Museo Nacional Thyssen-Bornemisza, Madrid

The duties of the King's Painter were wide-ranging: all sorts of works were required, from a painted family memorial to solo portraits in various sizes and versions. Holbein's workshop will have been kept very busy. It seems as if this very small and, from a present-day point of view, at first sight unremarkable portrait is the only one to have survived that is actually by Holbein himself. But it nonetheless packs a real punch—not only the painting but also its purpose.

Against an ultramarine background, Henry VIII fills the entire picture surface and is clipped at the edges to suggest a powerful and very physical presence. The body is at a slight angle and has the effect of acting like a strong pedestal for the regal head. The portrait radiates a disciplined and controlled energy which could erupt at any moment.

The King's tunic looks truly noble with its gold-embroidered collar and sleeves and the set rubies which have been applied to it. Henry is wearing a gold chain which is decorated with his repeated initials. It appears to have been made, or at least selected, to match his costume perfectly. The King set great store by his clothing. As the Venetian diplomat Sebastian Giustinian reported in 1519, Henry spent 16,000 ducats of his total household budget of 100,000 ducats on clothes alone. The King of England was considered to be the best-dressed of all rulers. Holbein has recorded this in corresponding elaborate and brilliant manner, from the precious ultramarine of the background to the shell gold for the chain, collar and sleeves as well as to the varnished shades of red for the rubies. Initially we see the picture as a modest whole until we draw nearer and admire the exquisitely painted details.

The question remains as to what the purpose of this small but elaborate portrait can have been. It was common practice for the royal houses to exchange such small-format portraits. In the inventory lists of the English court, we find mention of portraits, amongst others, of the Emperors Maximilian I and Charles V, of Margaret of Austria as well as of King François I of France. Similarly, Henry's portrait was to be found at the other courts. This special painting was probably intended for King François I of France, who was Henry's perpetual rival. With the outstanding and unusual quality of Holbein's portrait, Henry had surpassed François and thus, so the royal thought process, the English King was superior to the French monarch with regard to authority, magnificence and powerful dominance—and it goes without saying, not only in his portrait.

Christina of Denmark, 1538

Oil on oak panel
179.1 × 82.6 cm
The National Gallery, London

This is the only full-figure female portrait by Holbein that is still in existence. It was produced under unusual circumstances. Jane Seymour, the third wife of Henry VIII, died in 1537, two weeks after the birth of her son, the later Edward VI. During Henry's search for a new wife, Christina of Denmark (1521/2–1590) was included on the short list. She was the daughter of King Christian II and was also the niece of Emperor Charles V, which was considerably more important in this context. The Emperor was hoping for an alliance with England against France as a result of this connection and had therefore suggested the marriage. Christina was about 16 years of age and had been the widow of Duke Francesco II Sforza of Milan for over two years following the latter's death in 1535. The Duke had married Christina in 1533 but the marriage had not been consummated because of her youth—she was 11 years old at the time. In 1537, she returned to her home town of Brussels and was still in mourning for her deceased husband, whom she had evidently greatly revered.
Henry VIII sent his court official Philip Hoby and his painter Hans Holbein to paint a portrait of the chosen candidate, so that he could see what she looked like. The English ambassador in Brussels had already sent portraits, but remarked that they were "not as good as the matter requires, nor a match for what the aforementioned Mr Hans would achieve". Holbein arrived in Brussels on 10 March 1538, and two days later, he was granted an audience of three hours in order to make drawings of the young widow. During this short time, he probably recorded the face, the much-praised elegant hands and the figure as a whole. None of the drawings has survived. On 18 March, Holbein was back in London again, where he created this unusual painting. We can see the delicate Christina in her black velvet mourning cloak, standing in front of a blue-green wall, on which she casts a sharp shadow, as well as a door or window embrasure on the right. The prominent shadow on the wall ought to be visible on her face as well, or at least on her nose and hands. But as if to emphasise the contrast between her porcelain-like skin and the black velvet, the face and hands are almost shadow-free. There are few coloured accents, such as the fur trimming on her cloak, which interrupts the black, and her red lips and the ring.
Heinrich VIII was delighted and evidently fell in love with Christina at first sight. People noted that he had musicians play for him all day long. We do not know whether this was when he saw the drawings or the painting, however. Nonetheless, Christina refused to marry him. She had evidently heard too much about the King who had had his second wife beheaded, may have poisoned the first and then had the mother of his son cared for so incompetently that she died in childbed.
In 1541, Christina married François I, the later Duke of Lorraine (1517–1545), in Brussels. According to a marriage contract drawn up when he was still a child, François was actually destined to marry Anne of Cleves (pages 102/3). At the end of Christina of Denmark's life she returned to Italy which, as the widow of Francesco Sforza, she was entitled to do.

Anne of Cleves, 1539/40

Resin tempera on parchment, mounted on canvas
65 × 48 cm
Musée du Louvre, Paris

In the case of Christina of Denmark (pages 100/101), Henry VIII had experienced how quickly one can fall in love at the mere sight of a portrait. In the case of Anne of Cleves (1515–1557), he learned how far removed on occasion the wish can be from reality. After Christina's refusal, the King and his Lord Privy Seal Thomas Cromwell (pages 86/7), continued the search for a new bride who would suit Henry both politically and optically. Cromwell believed that he had found the answer in Düren near Aachen, in the person of Anne of Cleves. She was the daughter of Johann III, Duke of Cleves (1490–1539), a possible ally against Emperor Charles V and King François I of France. Once again, Hans Holbein was sent across the English Channel to produce drawings for the King's consideration. Holbein evidently began to work on Anne's portrait while he was still travelling, because it is painted on parchment, which was considerably more practical on a journey than the more usual wooden panels. The subject was 24 years of age and is dressed in an elaborate velvet dress that is extravagantly adorned with gold borders and pearls. The entire painting is a harmonious blend of shades of red, gold and dark green, and radiates a slightly remote aura. It shows Anne of Cleves in a front-view pose with regular features and a reserved, perhaps slightly naïve gaze.

The question is, to what extent Holbein portrayed reality in his picture, and to what extent he aimed to distract from any flaws—possibly even in accordance with Cromwell's wishes—by focusing on her magnificent costume. In any case, Henry VIII was enamoured and signed the marriage contract in Anne's absence on 6 October 1539. Anne finally arrived in London on 27 December 1539 with her entourage of 263 persons and 283 horses. The King was, to put it mildly, "not amused". Henry tried everything to prevent the marriage, because the "Flanders Mare" did not meet with his expectations at all. Nonetheless, the betrothal took place on 6 January 1540. The King, however, did not feel inclined to consummate the marriage, finding Anne of Cleves too repulsive and himself too disappointed. This time, Holbein had evidently not made the right choice while oscillating between courtesy and reality. The royal couple was divorced on 9 July 1540; Anne abdicated and became known as the King's "Beloved Sister". She was treated with consideration by him despite everything. Cromwell did not survive the disastrous marriage and was beheaded three weeks later. Anne survived Henry and all his wives and was buried as a former Queen in Westminster Abbey.

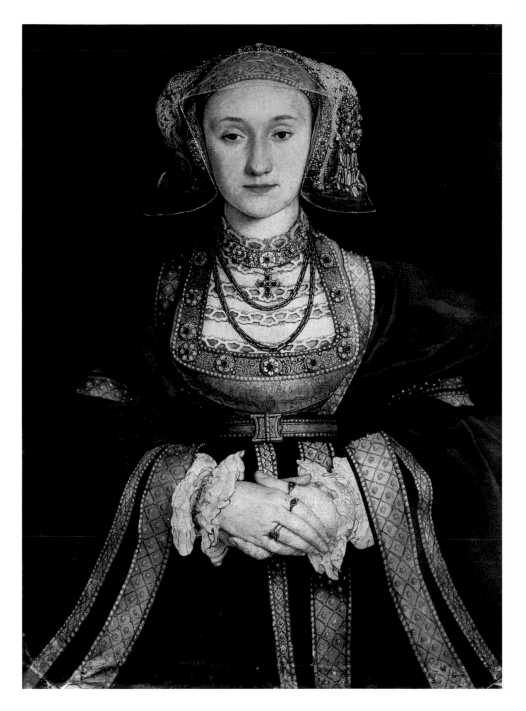

Edward VI as a Child, probably 1538

Oil on panel
56.8 × 44 cm
National Gallery, Washington

Edward was born on 12 October 1537 as the long-awaited son of King Henry VIII.
The joy at the birth of a male heir to the throne at long last was only brief, however,
because Jane Seymour, Henry's third wife and queen, died just twelve days after the
prince's birth. Hans Holbein took advantage of the opportunity—and perhaps also
to confirm his position as court painter after his return from Basel—by painting the
child in full magnificence, as befitted an heir to the throne. This is not the portrait
of a beloved child, as a comparison with the likeness of his own daughter Katharina,
painted ten years previously, clearly shows (pages 80/81); it is above all the image
of a successor and son and heir of a young dynasty. And that is how he is portrayed:
The Prince of Wales, just over one year old, is shown in a regal pose behind a
balustrade covered in green. In one hand he grasps a golden rattle, which he is
holding like a sceptre; the other hand is raised in greeting, or in this case, as the
future head of the new Anglican Church, in blessing. The inscription was composed
by the Humanist and diplomat Richard Morrison, a confidant of Thomas Cromwell,
and is a paean of praise for the father, disguised as an address to the son. If the
young heir were to surpass his father, this would make him a king who could be
outdone by no other monarch.

In painterly terms, the portrait also fulfils the highest expectations. The gold brocade
of the sleeves gleams magnificently with the shell gold that Holbein has used. He
applies it in fine strokes and lines and leaves the background shining through in
places, thereby achieving a painterly effect using graphical means. It harmonises
with the brilliant red, which will have been even more intense at the time. The
bonnet with the ostrich feather has also changed, because the patches which are
brownish today were originally decorated with silver leaf. The background has
become badly discoloured over the years: investigations have indicated that here
Holbein used smalt, a cobalt-blue pigment that produced a light slate grey-blue
on the painting, a colour that probably looked suitably regal together with the
clothing.

Holbein presented the picture to Henry VIII as a gift at New Year 1539. The King
was pleased with what he saw, because he gave Holbein a golden goblet weighing
almost 300 grammes as a token of his thanks. Edward's life was to be a short one. He
was a sickly child and was brought up very strictly. He was crowned on 25 February
1547 following his father's death and died himself in 1553 at the age of only 15.

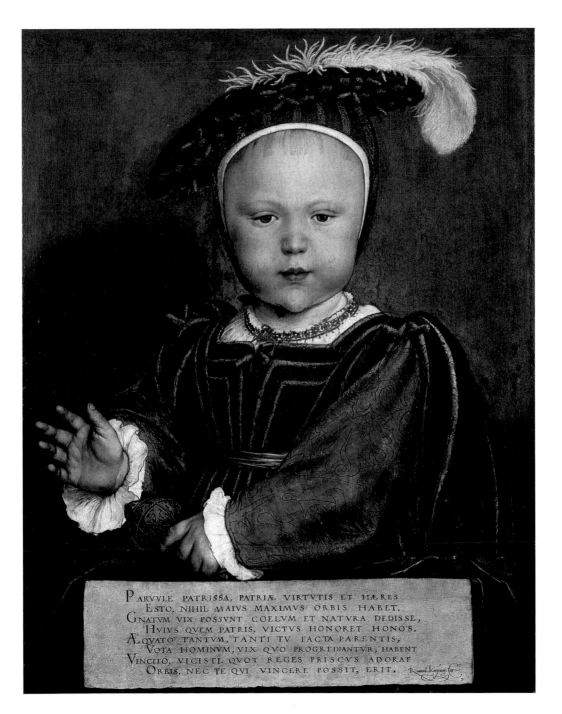

PARVVLE PATRISSA, PATRIÆ VIRTVTIS ET HÆRES
ESTO, NIHIL MAIVS MAXIMVS ORBIS HABET.
GNATVM VIX POSSVNT COELVM ET NATVRA DEDISSE,
HVIVS QVEM PATRIS, VICTVS HONORET HONOS.
ÆQVATO TANTVM, TANTI TV FACTA PARENTIS,
VOTA HOMINVM, VIX QVO PROGREDIANTVR, HABENT
VINCITO, VICISTI, QVOT REGES PRISCVS ADORAT
ORBIS, NEC TE QVI VINCERE POSSIT, ERIT.

Jane Small, c. 1536

Watercolour on parchment
Diameter: 5.2 cm
Victoria and Albert Museum, London

It was the Flemish painter Lukas Horenbout, a contemporary of Holbein, who introduced miniature portraits to England in the 1520s. These tiny pictures and portraits were usually painted in watercolours on parchment and were then mounted so that they could be worn as an item of jewellery. When Hans Holbein arrived in London for his second sojourn in England in 1532 and was later employed as the King's Painter, he was also permitted to work for other clients. He was in any case in great demand as a portraitist, and so he added miniature versions to his portfolio. Here, too, he very quickly outstripped his traditional colleagues, because, as we know from his marginal drawings for *In Praise of Folly* for Erasmus of Rotterdam (page 12) and his *Dance of Death* images, which only measure 6.5 by 4.8 centimetres, his tiny images display an incredible quality. In his so-called "English Sketchbook" he collected drawings which are no larger than spectacles lenses and which nonetheless narrate entire stories from the Old Testament. In this respect, painting miniature portraits made a welcome change for Holbein. Of the few which have survived, that of Jane Small is one of the most elegant. Jane Small (c. 1518–1602), who at that time was still probably Mrs Pemberton, was 23 years of age, as is noted on the picture in typical Holbein manner. The carnation in her neckline and the sprig of rosemary (?) in her hand suggest a betrothal with the prosperous cloth merchant Nicholas Small. It was probably on this occasion that Holbein painted her portrait in the little circle, which measures only just over five centimetres, thereby capturing her gentle personality. In was with good reason that in 1604 the Flemish writer and artist Karel van Mander praised Holbein so highly in his *Schilder-boek*, the first collection of artists' biographies to be published north of the Alps: "And since he had at his disposal a better, indeed an outstandingly good, drawing technique and perception and was blessed with greater intellect, he far surpassed Lukas [Horenbout]—as far [...]as the sun outshines the moon with brightness."
Holbein's quality set standards and helped this new but already very popular branch of portrait painting to great acclaim over the coming decades. One of his most famous and successful successors in this field was the English painter Nicholas Hilliard (1547–1619).

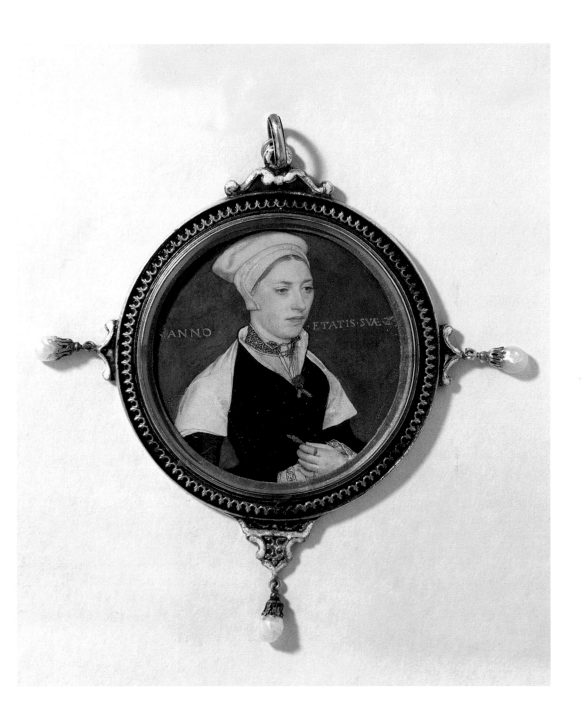

John Chambers, c. 1543

Oil on oak panel
58 × 39.7 cm
Kunsthistorisches Museum, Vienna

Hans Holbein created one of his last works in connection with a major commission. In 1540 a parliamentary decision had merged the Guild of Surgeons and the Company of Barbers, in order to organise and improve medical treatment in England. To mark the occasion, Holbein was to create a large group portrait which can be seen to this day in the Barber-Surgeons' Hall in London. It shows Henry VIII, who is presenting the first President of the new Company of Barber-Surgeons with a sealed certificate, together with further members who are identified by name. To Henry's right the Court Apothecary and his two personal physicians, William Butts and John Chambers can be seen.

John Chambers (1470–1549) was the main protagonist behind the fusion. He was the personal physician of Henry VII and Henry VIII, and between 1525 and 1544 was also the Warden of Merton College in Oxford, whose library was founded in 1373 and is the oldest continuously used university library in the world. At the same time, he was also a clergyman in charge of ample prebends.

Holbein used the drawing which he had made for the group portrait when producing this solo portrait of the experienced physician—a further example of the artist's economical work processes. Holbein shows Chambers entirely without accessories of any kind, with the exception of the gloves, which might indicate his noble status. He has even dispensed with the inscription stating the subject's age. It was added later and makes Chambers older than he actually was. At the time the painting was made he was not 88, but 'only' 73 years old. Chambers looks as if he is concentrating. He seems very tense, as is evident in the way he is pulling at his gloves. We think we can detect plenty of energy in his face, but also a hint of frustration resulting from a long life and a wealth of experience.

While the portrait of Derich Born (pages 88/9) was, as it were, an idealised image of the challenges posed by youth, so the image of Chambers is a prototype for the representation of age which has experienced life in all its aspects.

ÆTATIS ✦ SVE ✦ 88 ✦

FURTHER READING

Buck, Stephanie, *Hans Holbein*, Cologne 1999.

Buck, Stephanie, *Hans Holbein the Younger: Painter at the Court of Henry VIII.*, London 2003.

Foister, Susan (ed.), *Holbein in England*, ex.cat. Tate Britain, London 2006.

Hans Holbein the Younger. The Basel Years 1515–1532, ex.cat. Kunstmuseum Basel, Munich 2006.

Holbein and the Court of Henry VIII. Drawings and Miniatures from the Royal Library, Windsor Castle, ex.cat. National Gallery of Scotland, Edinburgh; The Fitzwilliam Museum, Cambridge; National Portrait Gallery, London, Edinburgh 1993.

Mantel, Hilary, *Holbein's Sir Thomas More*, New York/London 2018.

Rowlands, John, *Holbein. The Paintings of Hans Holbein the Younger*, Oxford 1985.

Wolf, Norbert, *Holbein*, Cologne 2004.

PHOTO CREDITS